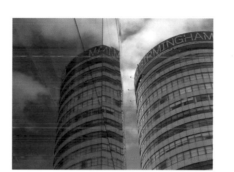

Celebrating the building of Bullring with unique photographs and panoramic constructions by Michael Hallett with additional contributions by Adrian Ensor, Gil Gillis, Peter James, Luke Unsworth & Chris Upton.

Foreword by Councillor Sir Albert Bore

supported by

THE **BIRMINGHAM**
THE **ALLIANCE**

BULLRING

the heart of Birmingham

MICHAEL HALLETT & PETER JAMES

TEMPUS

First published 2003

Tempus Publishing Limited
The Mill, Brimscombe Port,
Stroud, Gloucestershire, GL5 2QG

British Library Cataloguing in Publication Data.
A catalogue record for this book is available from the British Library.

ISBN 0 7524 3041 6

Typesetting and origination by Tempus Publishing Limited
Printed in Great Britain

CONTENTS

ACKNOWLEDGEMENTS

As we write this it is some thirty months since we started our project of recording the construction of Bullring. What began in the solitude of one man's Odyssey has finished up as a tremendous team effort, and it is only now that we begin to realise the extent of our fascinating journey.

We would like to thank various people that were involved with the overall project: from The Birmingham Alliance Jon Emery, Mel Evans, Anna King and Vic Michel supported the project and allowed it to happen. Without them, the project would have been very different. We thank the Birmingham Chamber of Commerce and in particular Sue Battle, Billy Carslaw and John Lamb along with their advisors Alan Hudson and Michael Jefferies. We would also like to thank the many people we visited from the arts, industry and commerce to talk about our project and for their time and support. Michael Hallett acknowledges the Casio Camera sponsorship on which all the more recent images have been made and thank Emily Aldis and the digital imaging team for their support.

Many people have been involved with the exhibitions, both directly and through sponsorship. For *Bullring Preview* at the Birmingham REP we thank both Nigel Cairns and Clare Jepson-Homer; for *Bullring at Focus* displayed at 'Focus on Imaging' at the NEC we thank Mary Walker for giving us the exhibition space and for supporting our audacity to introduce the constructions to a wider audience; and Chris Kay at Loxley Colour for producing the one metre wide panoramic images. As we write this the *Bullring* exhibition to coincide with the retail opening of Bullring is still in the future. We thank the various venues for allowing us to exhibit the work, and we thank the Church of St Martin in the Bull Ring and particularly Liz Harris and the Revd Magdalen Smith. Through Peter James the Birmingham Libraries have backed the project in numerous ways and this we would acknowledge.

So many people have been generous in their support of the book. We thank Jon Emery and James Utting as well as Roger Borrell, Richard Green, John Heeley and John Pratt for their personal visions. Stephen Hetherington's view of Birmingham and Councillor Sir Albert Bore's Foreword demonstrate the depth of feeling they have for their city. In Chris Upton and Peter James' essays various photographers have allowed us to reproduce their photographs for which we thank them. Their camera vision has enhanced the story.

Not least we thank the market traders and the people of Birmingham who accepted the scrutiny of the camera and shared their enthusiasm and pride for this world class city.

Michael Hallett
Peter James
June 2003

FOREWORD by Councillor Sir Albert Bore

This book is not a history. It is, nonetheless, an important city archive. The birth of Bullring is a key and dramatic element in a tapestry of change and regeneration that is the outcome of a vision for a revitalised Birmingham. It is important that the story of the Bullring is recorded. Michael Hallett's panoramic constructions do indeed capture the scale of the construction in a unique, imaginative style that reflects the innovative concepts that fired those who created the designs. Through this technique we, as viewers, become involved and not just bystanders.

At the heart of the vision for the city has been a recognition that the vitality of the changes can only come from its people. The old Bull Ring, and the markets before it, always had that at their heart. The evocative images of the old markets on the following pages memorably capture that vitality. I am confident that Bullring will once again draw in residents and visitors alike, reflecting the rich mixture of city life that is the diversity of Birmingham.

I believe that, as we move into the 21st century, we can all be proud of our city as it combines its heritage in a renewed confidence with bold dynamic new ideas and designs. Other images in the book illustrate that Birmingham continues to be a city conceived and built in a tradition of innovation and boldness. In that spirit, an exciting new personality is developing with increasing momentum. The people of Birmingham are seen again to be proud and confident of their place in the nation's culture and heritage – and we do have much of which to be proud.

Our achievements are not only reflected in the high profile and visible squares and buildings most often seen by visitors, but are also evident in our neighbourhoods. Flourishing lively communities exist where once they did not. Castle Vale is transformed to be a role model for what is only possible through partnerships that include residents. Around the city increasingly residents are identifying with the opportunities they can achieve by working together to find constructive solutions to old problems.

Still to come will be the excitement of the widespread new ideas for Eastside beyond Bullring. Those started with the Aston Science Park and then Millennium Point. Now, with the removal of the boundary that was the Masshouse high level ring road, the city has been re-opened towards the south, so that new and striking vistas will open up over the next few years. Moor Street Station will reflect again the pride of 'God's Wonderful Railway', the Custard Factory village already provides an environment in which creativity can be realised. Then there will be the Library and the Park extending the heart of the city, enabling a fresh and imaginative view to be taken of Paradise Circus.

The city can never stand still. It is, therefore, vital that all the changes are recorded so that our legacy can be passed on to our successors.

I am grateful to the team who have assembled this record, for their imagination in perceiving the importance of the task and for the way in which the birth of Bullring has been portrayed in strikingly unique images.

Councillor Sir Albert Bore
Leader, Birmingham City Council

Councillor Sir Albert Bore

BRINGING VISION TO REALITY

Bullring's role in Birmingham's physical and economic regeneration has been acknowledged as the new model for future city centre redevelopment projects across Europe. Even before its completion, the strength of Bullring's retail offer was being cited as the single most important component in the city's transformation into a world-class destination. Through Bullring, Birmingham finally has a retail line-up to match the city's status as one of

Europe's leading capitals for business, culture and entertainment. Our vision to restore Birmingham's historic importance as a major trading centre has been fulfilled.

Harnessing the enthusiasm and commitment from a vast number of people to bring about the realisation of Bullring has been one of the most challenging and rewarding aspects of its development. Bullring is a totemic symbol of Birmingham's change and discovery. It is a landmark achievement, not just in terms of its enormous scale and innovative architecture, but also in terms of the partnerships evolved during its creation. Bullring will become a symbol of best practice for generations to come.

Jon Emery
Development Director for Bullring

Our vision for Bullring has been to return it to its rightful position as the very heart of Birmingham's retail quarter. To 'heal' the 'gaping hole' that the old 1960s Bullring created with a new open, friendly environment whose buildings relate in scale and 'grain' to those around them.

We also wanted to create major new public spaces within Bullring, adding to the City's existing squares and providing an appropriate and dignified setting for the historic St Martin's Church.

James Utting (Architect)
Benoy Design Director responsible for Bullring

Benoy Design Director James Utting's vision of Bullring

PERSONAL VISIONS

John Pratt

Birmingham and the Bullring go together like London and Piccadilly. It presents an important image to the world and its regeneration is indicative of all that is happening in our great city. The new Bullring will be a monument to public and private enterprise combining to help create a city of true world standing.

John Pratt
President, Birmingham Chamber of Commerce & Industry

Richard Green

The Bullring development will quicken the pace of change in Birmingham as the City Centre expands eastwards. It will become the latest expression of the City's confident outlook on life, as it redefines and extends our retailing offer.

Perhaps its strongest asset will be as a new meeting place for every part of our community, with major new squares, pedestrianised streets, cafes and malls clustered around a rejuvenated St Martin's Church.

For me it is the culmination of dedicated and committed partnership working between the City Council and The Birmingham Alliance, showing that when the public and private sectors work together effectively the results can be dramatic. The photography project has imaginatively captured much of the scale and complexities of this.

But nothing will be as dramatic as the new Selfridges building – a truly iconic and extraordinary piece of architecture!

Richard Green
Director, Eastside

The opening of Bullring and the transformed cityscape will give us a much stronger product with which to penetrate day visit and short break markets.

Birmingham can now seize the mantle of regional shopping capital – a tantalising but nonetheless achievable prospect.

John Heeley
Chief Executive, Marketing Birmingham

I hope the Bullring becomes a beacon of success for the new Birmingham. I arrived here just as the old Bull Ring was being destroyed and it left a chasm in the retail heart of the city.

The new Bullring will heal that wound, but I hope it is more than just a temple to shopping. I would like it to be a place where people from all colours, classes, races and religions can enjoy the achievements of this vibrant, thriving city.

Roger Borrell
Editor in Chief, *Birmingham Post and Mail*

John Heeley

Roger Borrell

BULLRING ICONS: THE ROTUNDA

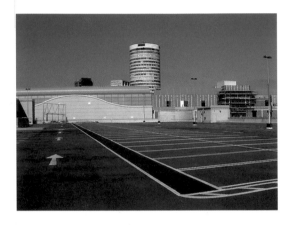
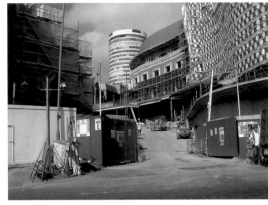
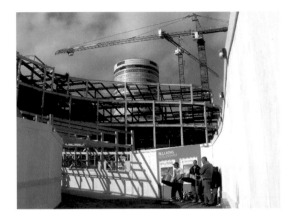
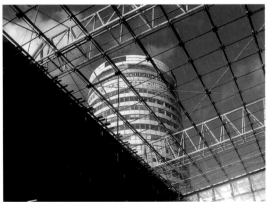

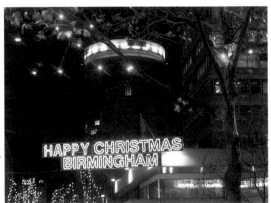

BULLRING ICONS: THE SELFRIDGES BUILDING

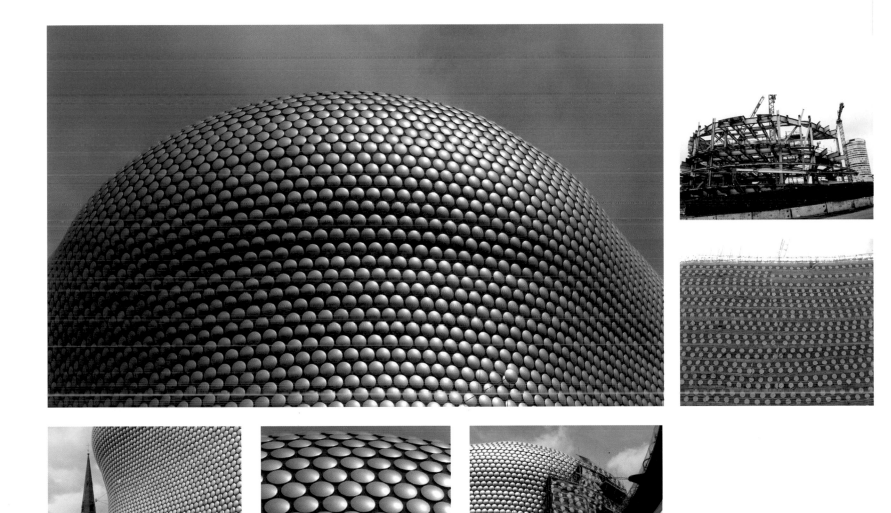

FROM BULL RING TO BULLRING

(Above) *The Bull Ring in the 18th century,* engraving by Harry S. Sears, 1938.
(Opposite): *The Bull Ring,* c. 1970, photographer unknown.

The city of Birmingham is well used to staging big events. But for the last three years the biggest show in town has undoubtedly been at the bottom of New Street. First there came the bulldozers, then the dancing cranes, and finally a spectacular new building rising up out of an immense hole in the ground. After years of planning and negotiation, demolition and construction, Bullring was finally arriving.

You don't need to know much about Birmingham to understand the weight of expectation here. From medieval church to Market Hall; from Onion Fair, manor house and moat, to the Chartist Riots and the Blitz. No place in Birmingham carries as much history as the Bull Ring. For centuries anything of importance that happened in Birmingham took place in the Bull Ring, and however much the city centre expands beyond its old boundaries Bullring still has a feeling of being at the heart of things. What the people of Birmingham have been witnessing with an increasing sense of anticipation has not simply been Europe's largest construction site, but the biggest heart transplant ever undertaken.

Beyond the complexities of the civil engineering, there's a strong sense of reconnection going on. Not only a connection between the markets and the city centre, but between new Birmingham and its old predecessors. To understand what Bullring means to Birmingham, and has always meant, we turn back the clock some 1,000 years.

That sense of connection was clear enough a couple of years ago, when the Bullring excavations went deep into the bedrock, and archaeologists were knee-deep in top soil in Park Street. What they found in the footings of old buildings and those scraps of leather and pottery was a chain of history that takes the Bull Ring back to the early Middle Ages. Every generation of archaeologists for the last century has had the opportunity to dig in one Bull Ring or another, and they're always asking the same burning question, one that has tested every historian of Birmingham since William Hutton. How did a settlement that was worth only one pound, when William the Conqueror's commissioners surveyed it in 1086, come to be a city of one million people and the largest manufacturing centre in the country?

The Bull Ring probably holds the answer. In 1166 Peter de Birmingham, the lord of the manor, was given the right (by royal charter) to hold a market every Thursday 'at his castle in Birmingham'. The very idea of a castle in the middle of Birmingham still comes as a surprise to many and they will, of course, look for it in vain. A multi-storey car-park at the bottom of Bradford Street occupies the approximate site, and its ancient moat is only preserved in a road name.

This charter probably holds the key that unlocks the door to Birmingham's history. For the lord of the manor it was the opportunity to levy tolls on the goods sold; for the traders it meant the first chance to go to market anywhere in Warwickshire. Nowhere in the whole county had a market before Birmingham and it put an insignificant Anglo-Saxon settlement on the map. Who knows what went on between these two charters, but we can guess that it involved house-building, street planning and perhaps the construction of a small chapel or church. Within a few short years the Bull Ring became what it would be for the next 900 years: a place to pray and a place to shop and do business. And where there was trade, of course, there was also manufacturing.

by Chris Upton

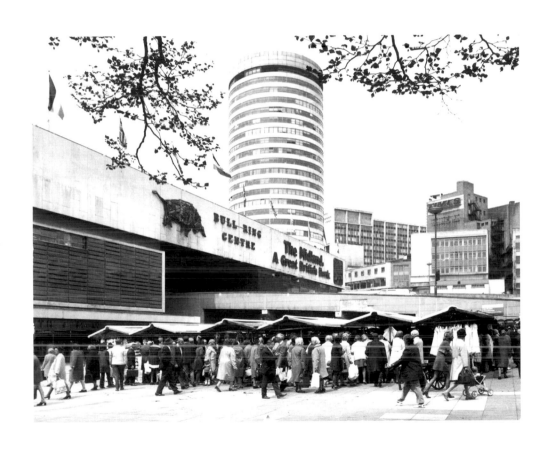

With the River Rea running through it Digbeth was necessarily the city's first industrial estate. Running water was needed for the tanning of leather, the fulling of cloth and to power the first corn mills, and Birmingham slipped easily into these tried and tested medieval crafts. But by the time the town received its first tourists - Tudor antiquarians they were - it had already undergone something of an industrial revolution. Leather and cloth were out and metalware was in. William Camden found the place 'full of inhabitants and echoing with forges' as he made his way up Digbeth and into the market.

The town was even more crowded on fair days, for the enterprising lords of the manor also applied for, and received, royal permission to hold a four-day fair at Ascensiontide. By 1400 there was a Michaelmas fair as well. All in all, the Bull Ring was looking like a pretty shrewd investment, not only for its owners, but also for the traders who chose to set up shop nearby. But salubrious and sweetly-smelling it certainly was not. At one end of the animal chain were the slaughter-houses. Then came the Shambles or butchers' shops, already beginning to encircle the old market-place. Finally there were the glue-makers, the bone and horn manufacturers, the tanners and whip-makers, all making a decent living from what could not be eaten. The Bull Ring was nature in the raw.

The lords of the Birmingham manor jealously hung onto that charter for seven centuries. Long after their castle had become an iron-works and the original family were laid to rest in St Martin's church, control of the market and its tolls remained firmly in the hands of the lord and his officers. Sadly for the de Birminghams it was no longer them. In 1535 Edward de Birmingham found himself under arrest in the Tower of London and was forced to make over the manor to Henry VIII. From that date onward no lord lived in the old manor house, and it was left to crumble and decay.

But the lordship, its officers and its privileges lived on. The high bailiff continued to proclaim the fairs and ensure that customers at the market were not under-sold; the low bailiff collected rents for the stalls; the low tasters checked that the fish and meat were not unwholesome. Each year the officials went on procession before the Michaelmas Fair, if only to show off their uniforms and to remind the town that the old order still prevailed.

But the old order was changing sure enough, and the redevelopment of the Bull Ring at the turn of the 19th century was as radical as any it has undergone since. The men who dragged the area, kicking and screaming, out of the Middle Ages were the Street Commissioners, empowered (in the absence of a town council) to light, pave, cleanse and widen the streets of Birmingham, and to knock down anything that stood in their way. Like the high bailiff with his set of weights on market days, the Commissioners weighed the Bull Ring in the scales and found it wanting.

Tidy men by nature, the Commissioners considered the Bull Ring too rambling and chaotic for the new age of reason. St Martin's church and churchyard were clogged up by butchers' shops and stalls, a building called the Roundabout House blocked the route into New Street and the market itself had spread out engulfing most of the lower town – corn in Corn Cheaping, pigs in New Street, flowers in Moor Street and cattle in Dale End. There was a solution to this, and it involved subtle legislation and a lump hammer.

Within a generation the Bull Ring had become the open market familiar to anyone that remembers Birmingham

before the 1960s, but change came at a cost. Down came the Roundabout House and the Shambles; down too came the Old (or High) Cross, which for centuries had sheltered traders and their chickens on the ground floor and hosted public meetings and court sessions above. The bell on its roof had announced the commencement of the market at 10.00 in the morning and its closure at 3.00 in the afternoon. Suddenly in August 1784 the Cross was gone, and to many it must have seemed that Birmingham was slowly and surely severing its links with the past. A satirical rhymester lamented its disappearance, and the (literally) knock-down price, in the local paper:

> Conscience's court by auction goes,
> Bidders, though few, the hammer does
> The business in a trice;
> At sixty pounds the blow is struck,
> Ten more knocks down the bell and clock:
> Commissioners – no price.

There were, however, compensations for the wholesale clearances. Not only did Birmingham now have a wide space in which to concentrate all its markets, the town had room to move in its first generation of public art. The man responsible for the earliest effort in that direction was none other than the high bailiff, Richard Pratchett, who saw that the demolition had left the old village pump exposed in front of the church. A rude and prosaic old thing it was too, by no means fitting for a town with upward pretensions. In 1808 Pratchett paid a local architect, William Hollins, to redesign it, and the pump was reborn as an Egyptian obelisk, complete with Greek honeysuckle and a lion's head that dribbled water down its chin. The Egyptian conduit, as it was called,

caused more derision than admiration, but such is the fate of public art so far ahead of its time as this was.

Far more successful was the statue that arrived to occupy the site of the Old Cross the following year. The very idea of erecting a statue to commemorate a hero of the high seas in land-locked Birmingham seems an odd one, but Viscount Horatio Nelson was more than a simple military commander. The victor of the Nile and Copenhagen was hero, celebrity and icon all rolled into one, and his death in the hour of victory at Trafalgar had only served to increase his fame. The people of Birmingham, whatever they thought of the Egyptian conduit, were far more prepared to accept public art on this subject. They raised a total of £2,000 and the Commissioners engaged William Westmacott to produce a statue of the great man. The work was unveiled on the day of George III's Golden Jubilee in 1809, the first of a score of national monuments raised in the good admiral's honour.

The bronze Nelson has seen as many changes in his surroundings as his well-travelled human counterpart. Over the years he has cast his one good eye over soap-box orators, quack doctors, the town's first pillar box and the daffodils that decorated his plinth each Trafalgar Day. And if he was still looking, in 1861 he saw the hotel renamed in his honour demolished to make way for a fish market. Nelson must have smiled at the strange irony of that one. One patriotic citizen called Joseph Farror even bequeathed sixpence a week in perpetuity to keep the statue clean. With Lord Nelson to console them, the people of Birmingham no longer missed the Old Cross.

But the Street Commissioners were not finished with the Bull Ring yet, not by a long chalk. In 1824 they bought the market tolls from Christopher Musgrave, then

lord of the manor. The cost (at £12,500) seems high, but within half a century it was probably worth twenty times that sum. More importantly, the Street Commissioners had the energy, the foresight and the cash to add value to their investment, and turn the old market into a commercial machine worthy of a town of 150,000 people, and equally capable of feeding them.

Within a few years the new owners of the Bull Ring did what each new owner has done ever since: they redeveloped it. By 1834 they had cleared the area between Philip Street and Bell Street and erected a huge market hall, big enough to contain 600 stalls, and spacious enough to seat and entertain 4,000 poor people on the day of Victoria's coronation. The architect was Charles Edge and the foundation stone was laid on February 23, 1833. At 365 feet long and 60 feet high, the Market Hall dwarfed any other building in the town, even the Town Hall, which was built shortly afterwards. For 130 years the Market Hall stood for cheap, indoor shopping in Birmingham: fresh salmon at a shilling a pound, caged birds for a few pence, pickpockets for nothing.

Even then the Commissioners were not done. In 1817 they built Smithfield Market on the site of the old manor house and moat for the sale of live cattle and horses, and they opened St Martin's Market in Jamaica Row for the sale of meat. When the Commissioners finally handed over control of the markets to the town council in 1851 they had expended some £106,000 on them. It was money well spent, as was already clear, for the annual revenue from market tolls had by now passed £6,500 and was still growing. And there was time for one last gesture by the Commissioners as they voted themselves out of existence and gave way to

the Corporation: the gift of a great bronze fountain to stand in the middle of the Market Hall.

The Corporation was no less energetic in building upon its acquisition. By the 1880s there were no less than six separate markets around the Bull Ring and something like 200,000 carts brought their produce in every year. Only the old open market that ran down from New Street to St Martin's – traditionally for the sale of plants, shrubs and live poultry – remained untouched by the expansion.

But the Bull Ring had more to offer than simply shops and stalls. It was Birmingham's public space, a place to debate and argue, to pass on news and to pick up gossip. From the 1760s one could read the newspapers in John Freeth's coffee house in Bell Street and share revolutionary sentiments over a cup of coffee. The Red Lion too hosted a radical debating society, generally civilised, though occasionally prone to spill out into the street. And debate could easily take a violent turn. In May 1810, for example, the *Birmingham Gazette* reported that 'a disposition to tumult was manifested by the populace of this town last week.' The cause of tumult on this occasion was the price of the Bull Ring potatoes, a trivial excuse for an uprising, one might think, but possession of the humble spud could mean the difference between a contented stomach and starvation. An argument in the market between women shoppers and stallholders turned into a full-scale riot, with most of the potatoes being re-deployed as missiles.

But the potato riot was small fare compared to the events that engulfed the Bull Ring in July 1839. This was at the height of the Chartist campaign for universal suffrage and once more the Bull Ring was the natural place to vent one's spleen. Such meetings were, strictly speaking, illegal

and the mayor of Birmingham sent for the Metropolitan Police to break them up. Sixty policemen tried out the newly opened railway line to Birmingham, arriving in time to engage in hand-to-hand combat with the Chartists. James Jaffray, an eye-witness to the battle, described the scene:

The police fought their way to the standard-bearers and demolished the flags, whilst others knocked down all who opposed them. For a moment they partially cleared the Bull Ring, but the people rallied, some tore down shutters of the shops in the neighbourhood; others smashed them in pieces and supplied the crowd with bludgeons; others again picked up heavy stones, and thus armed they returned to the charge.

Two weeks later, on 15 July, the market was in flames and those who lived in the Bull Ring fled with their account books and whatever of their property they could carry. Even the Duke of Wellington, a man well used to war and destruction, thought the mayhem in Birmingham worse than any he had seen in his army days.

Mercifully for those who lived or worked around the market, it was not usually this eventful. But the Bull Ring could be hectic enough, especially on a Saturday night, when the market hall stalls were off-loading their stuff, the open market was flickering with naptha flares, and the whole place was teeming with life. Here was Birmingham life in all its richness, though 'rich' is hardly the right word. Italian women in their shawls, Irish families from the lodging-houses in Park Street, Jemmy the Rockman in his old military uniform dispensing cough candy, or Henry Holmes, who dressed up as Napoleon to sell 'the only French sausage rolls in Brum'.

It was on fair days, however, that the Bull Ring fully came to life. The ancient fairs, established by the medieval lords to fill their coffers, were still going strong well into the 19th century. The Michaelmas fair had become particularly associated with the arrival of the onion crop. Huge cartloads - the height of a house - trundled into the market, and the famous tripe-sellers of Digbeth gleefully sharpened their knives in anticipation. But a fair with merely onions has limited appeal. What lured most down to the Bull Ring those late September days were the side-shows. Bostock's and Wombwell's menageries made regular appearances and waxworks related the tale of the latest mass-murderer. Swing-boats, gingerbread stalls, jugglers and lion-tamers made up what was called, in the parlance of the day, a pleasure fair.

Unfortunately for the fair proprietors, and for the Bull Ring itself, the word 'pleasure' was not one to use in mid-Victorian Birmingham. The Town Council observed the traffic chaos and the general lack of sobriety and, like Queen Victoria herself, was not amused. On June 8, 1875 a motion was passed 'not to let in future any land belonging to the Corporation for the purposes of shows or exhibitions of any kind whatsoever in the Whitsuntide or Michaelmas fairs...' With that the pleasure fair decamped to the Aston, leaving only the onions, it was enough to bring tears to the eyes.

The fairs may have gone, but much in the Bull Ring was faring well as the 19th century made way for the 20th. Through a mixture of high-handed regulation, future planning and careful management, the Commissioners and the Councillors had together made a highly marketable product of the Bull Ring. On the one side there were the wholesale markets in Bradford Street, Jamaica Row and Bell Street, open to the trade for the sale of meat, vegetables and fish; on the other there were the retail areas, including a new Rag Market, set aside for market gardeners and others who

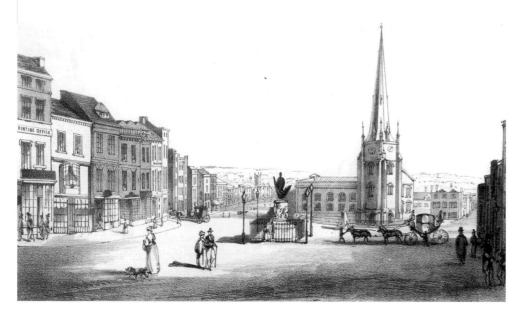

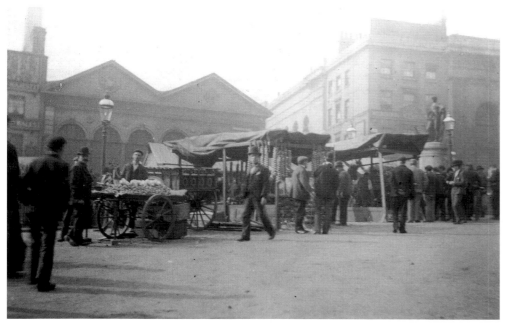

wanted to sell directly to the general public. By the end of the 1920s the markets occupied as much as nine acres in the city centre. And then there were the barrow-boys, who under-cut everyone and fiercely held onto their pitches on the edge. The shopkeepers in Bull street and Corporation Street might beat the Bull Ring in sophistication, but they could not match it in atmosphere.

Such an arrangement might have lasted for generations, slowly expanding and evolving, but the night of August 25, 1940 speeded things up rather suddenly. The incendiary bombs that fell from the sky that night could be said to have begun the redevelopment of central Birmingham. In the meantime the market hall was reduced to a roofless shell, albeit one that could be put into service as a kind of outdoor-indoor market. It hung around for another twenty years as first the Luftwaffe and then the planners worked out what to do with it.

The Blitz broke a chain of history. When the bombs stopped falling and investment began to flow again, the quest was not for the Bull Ring of yore, but for something new, something modern, something American. The chosen developers were Laing's, and their plan included the one thing that the Bull Ring had never had: a shopping centre. The steep slope that took New Street down to St Martin's (and toppled many an onion cart in its day) was to be replaced by a series of stratified layers, linked by escalators and underpasses, and crowning everything a landmark building called the Rotunda, a circular office-block of twenty-five storeys. The design was by James Roberts, who was also responsible for the striking curve of Smallbrook Queensway.

The metamorphosis was so swift and massive that it would have impressed even the Street Commissioners.

When the Duke of Edinburgh performed the official opening in May 1964 spectators gawped at the transformation. Where the Market Hall had stood there was now an enclosed garden, named after Birmingham's pioneering engineer and planner, Herbert Manzoni. Lord Nelson had taken roost on a platform overlooking Moor Street Queensway. The market stalls still tumbled down to the church, but above them the sky had been replaced by the Ring Road. And straddling the Ring Road was the biggest shopping centre outside the US, offering weather-proof shopping and stiletto-proof flooring. There was an entertainment complex too, and a direct connection with New Street Station. The whole lot had cost upwards of £8 million. Shoppers came in to savour the modernity of it all. Unfortunately for the shops, that is all they did.

Herbert Manzoni once famously said that one could only build for a single generation. For the 1960s' Bull Ring even that was overstaying its welcome. Despite the allure of its marble and vinyl, what we can now call the Old Bull Ring Shopping Centre was too remote, too cut off from the city to be the success it was heralded to be. Ahead of its time, it soon lagged behind the rest of the city, and began to show its age more even than the medieval church next door. The owners discovered to their cost that people did not appreciate picking their way through a concrete jungle to experience weather-proof shopping.

The fate of the Old Bull Ring was probably sealed by the late 1970s, perhaps as early as the day it opened. But designing a replacement has been a vast and delicate undertaking. But come September 2003 Birmingham can embrace its Bullring once more, and a thousand years of history comes full circle.

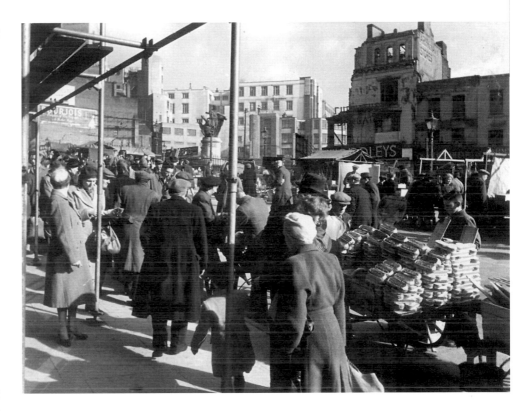

(Opposite above) *The High Town,* engraving by Peter Hollins, 1812.
(Opposite below) *The Onion Fair, Bull Ring,* by George Whitehouse, September 1901.
(Above) *The Bull Ring,* c. 1952, photographer unknown.

(Overleaf left) *Royal Visit to the Bull Ring,* Post & Mail Studios, 1963.
(Overleaf right) *The Bull Ring,* c. 1990, photographer unknown.

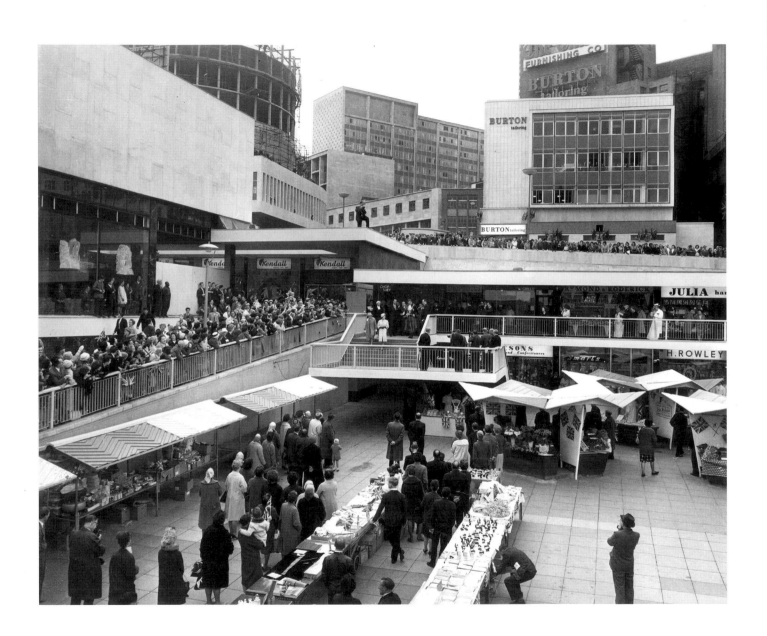

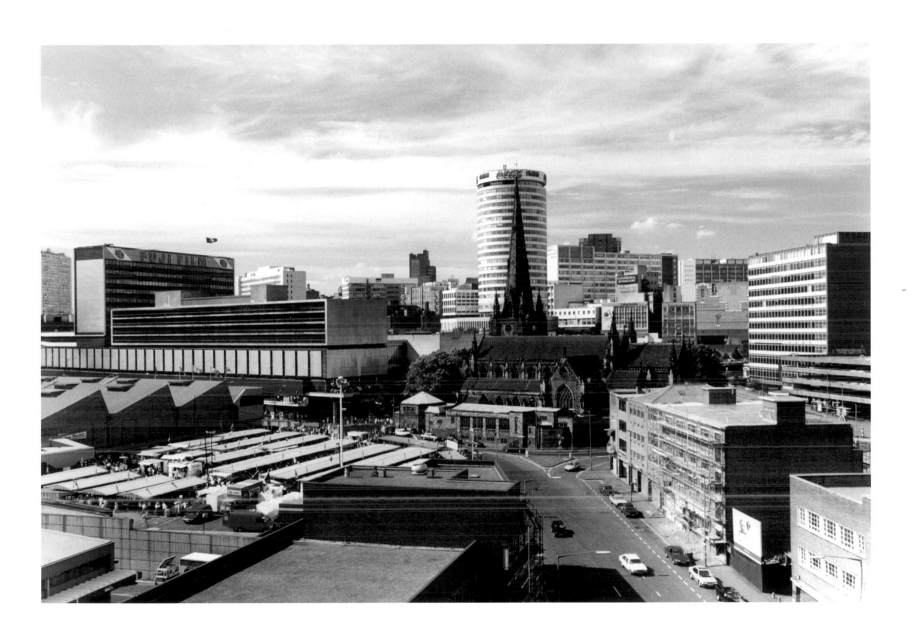

THE BULL RING IN FOCUS

(Above) *The Rotunda*, Matthew Murray, 1997. (Opposite) *The Bull Ring*, Neville Thompson, 1990.

Ask any Brummie where the heart of their city lies and nine times out of ten they will reply 'The Bull Ring'. For centuries past the markets around St Martin's-in-the-Bull Ring have provided Birmingham's citizens with food, clothing, domestic wares, toys, flowers and a multitude of other goods both new and old. But the Bull Ring is not just about shopping. The open-air and covered markets have also functioned as a social hub, a place where generations of people have come to meet, talk, reminisce, eat, drink, and worship together. Whilst these human and commercial dimensions have remained a permanent feature of the Bull Ring's historical landscape, the roads and buildings which physically define the market area have changed significantly. It is perhaps this mixture of tradition and change that gives the Bull Ring its unique character.

You get a good sense of the changing face and enduring character of the Bull Ring browsing through the collections of historical photographs, newspaper cuttings and books in Birmingham Central Library. These take you on a journey through time like that seen in the famous sequence in George Pal's famous 1960 film adaptation of H.G. Wells' *The Time Machine*. Old buildings are demolished making way for successive waves of rebuilding and redevelopment. Horse drawn cabs and hand drawn carts are replaced by trams, buses, cars and large commercial vans. The fashions worn by the traders and shoppers change as new styles replace old. The demographics of the Bull Ring also change as the increasing ethnic diversity of stall holders and shoppers alike brings a cosmopolitan variety of foodstuffs and goods to the market. And finally the new goods of one generation are recycled and sold as the antiques and bric-a-brac of the next. And so it goes on.

A traveller in H.G. Well's time machine might also notice one other feature recurring throughout such a journey; the presence of photographers seeking to record the buildings that give shape and the people who give character to the Bull Ring. In some respects the history of photographing the Bull Ring is a microcosm of the history of photography itself. Like the people and buildings they set out to record, the equipment and materials used by photographers change over time. The materials used to record these fleeting moments begin with glass plate negatives. These are replaced by sheet and roll film negatives and these in turn give way to the polished surface of memory cards used in digital cameras. The resulting prints also change from the sepia tones of the albumen print to the black and white of the silver gelatine print, through the various colour processes to today's modern ink jet prints. And finally, the styles and approaches of photographers change in relation to the technologies available to them and the function that their images are created to serve.

Despite these technical, functional and aesthetic variations, when viewed *en masse* it is possible to detect two main areas of interest amongst the photographs and photographers of the Bull Ring. Firstly a desire to records of the physical environment, in particular the process and results of changes wrought by successive demolition and regeneration projects. And secondly, a desire to record people who are the life blood of the Bull Ring and the social activity and events that take place there. These areas of interest are by no means mutually exclusive, for one naturally enough has a profound effect on the other. So let's climb aboard our time machine and explore the history of photographing the Bull Ring.

by Peter James

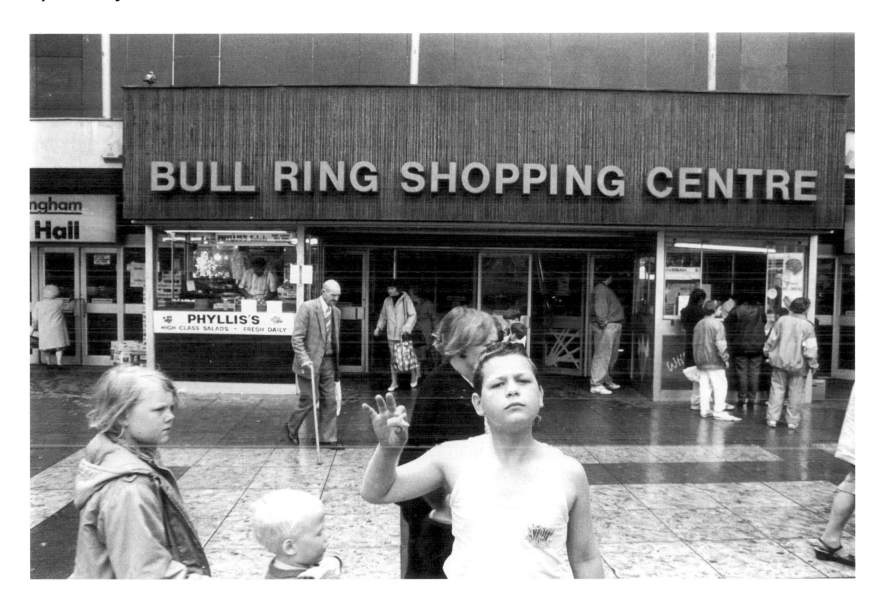

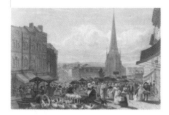

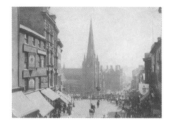

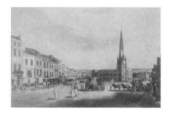

(Above from top) *The High Street Market, Birmingham*, engraving by W. Radclyffe from a sketch by David Cox, *c.* 1850; *View of the Bull Ring, c.* 1885, Poulton's Victorian Birmingham, photographer unknown; *The Bull Ring* by Peter Hollins, *c.* 1820, photograph of the picture by John Collier, *c.* 1880.

Amongst the earliest surviving photographs of the Bull Ring found in the library's collections are a number which record changes in one of the Bull Ring's landmark buildings. Dating from 1872, these trace the demolition of the 13th century church of St Martin's-in-the-Bull Ring. Serious deterioration in the materials used to erect the original church in 1290 combined with the failure of plans to restore the building meant that by the early 1870s St Martin's had fallen into a ruinous state. A scheme to demolish the church in order to make way for a new building designed by Alfred Chatwin attracted the attention of the Archaeological Section of the Birmingham Midland Institute. Founded in 1870 to record changes to the historic fabric of Birmingham's built environment, the Archaeological Section keenly aware of the camera's power to place on record people, buildings and events, instructed the professional photographer Robert White Thrupp to record the church's demolition. They also sought out illustrations showing the church before its demise and had photographic copies of these made so as to make comparative studies possible in the future.

One such image found amongst their collections is a drawing of the Bull Ring made in 1812 by Peter Hollins. This was photographed in the 1870s by John Collier, Thrupp's successor as official photographer to the Archaeological Section. This particular view of the Bull Ring, looking down the hill towards the statue of Nelson (erected in 1809) and the church of St Martin's beyond, appears to have been favoured by artists such as David Cox, who made a watercolour sketch from this position around 1820, and the commercial photographers working for firm's such as Poulton's in the latter half of the 19th century. St Martin's

Church continued to provide a visual and spiritual focal point in the Bull Ring throughout the 20th century and its presence, wrapped, cleaned and revealed once again during the current redevelopment, permeates the images made by contemporary photographers including Adrian Ensor, Michael Hallett and Luke Unsworth.

An edifice of perhaps equal standing in the folklore of the Bull Ring was the Market Hall. Just before the reign of Queen Victoria, Birmingham's Street Commissioners decided to pull down many of the old buildings around St Martin's church and create an open space for the town's stall-holders and street traders. They decided to get the bulk of them off the streets by building the Market Hall, which opened in 1835 and accommodated some 600 stalls. Whilst published sources suggest that many photographs of the Market Hall were taken during the 19th century, few original prints seem to have survived in the library's collections. However, amongst the more noted photographers to place their tripods in front of Charles Edge's building was William Jerome Harrison, the founder of the Warwickshire Photographic Survey. Harrison's survey sought to engage both professional and amateur photographers in making records of everything of interest in the county for the benefit of posterity. His photographic record taken in the 1890s therefore consciously records not just the building, but the scenes of everyday street life in the street in front of the Market Hall. An interior view of the Market Hall looking down the Central Avenue exists in the collection of photographs belonging to Sir Benjamin Stone, another key figure in the founding of the Warwickshire Photographic Survey. Like the members of the Archaeological Society, Stone copied earlier visual documents in order to build up

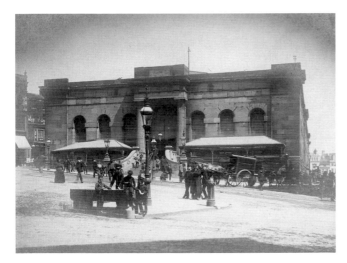

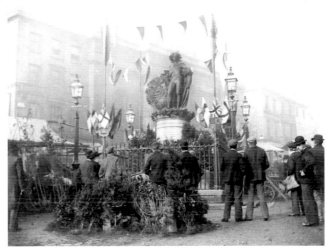

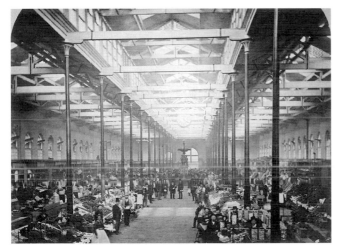

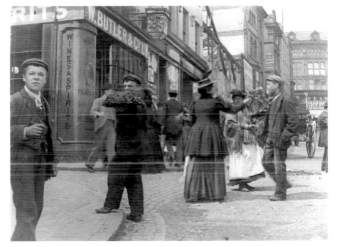

(Clockwise from top left) *The Market Hall, Bull Ring,* c. 1895, William Jerome Harrison; *Trafalgar Day, the Bull Ring,* Thomas Clarke, 1897; *'Kerb Merchants', Neapolitan Violet Sellers,* Thomas Clarke, July 1896; *The Birmingham Market Hall,* c. 1875, copy print, Sir Benjamin Stone collection, photographer unknown.

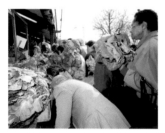

(Above) *Bull Ring*, Bob Kauders, 1990. (Opposite, clockwise from top left) *'Men Only' Manzoni Gardens*, Roy Peters, 1985; *Subway in the Open Market*, Roy Peters, 1985; *The Bull Ring*, Neville Thompson, 1990; *Christmas Fair, Bull Ring*, Jonathon Shaw; *The Bull Ring*, Neville Thompson, 1990.

the most comprehensive record of a given subject. This particular image is actually a copy of an earlier photograph probably taken some time in the late 1860s or early 1870s, showing the bronze fountain surrounded by figures representing various products and groups of flowers, fish and fruit designed by Messenger & Son and erected in 1851.

In the hand-written caption on the mount board Stone also notes that amongst the people present when the photograph was taken is one Jacob Wilson, Birmingham's last Town Crier. Wilson was just one of the many characters who have populated the history of the Bull Ring. Although people appeared in many of the views and streets scenes taken in and around the Bull Ring, it was not until the last decade of the 19th century that photographers seem to have made a conscious decision to record some of those whose livelihood depended on the markets. In the late 1890s Thomas Clarke and Percy Deakin, both members of the Birmingham Photographic Society and contributors to the Warwickshire Photographic Survey, took hand-held cameras into the markets in an attempt to capture snapshots of the 'kerb merchants' and flower sellers who plied their trade on its streets. Unlike the plate cameras of the 1860s-1880s whose operation depended on the use of a tripod, thus attracting the attention of any passers by, the smaller cameras, increased shutter speeds and faster emulsions available to Clarke and Deakin allowed them to capture candid moments and exchanges between traders and customers in the Bull Ring. The snapshot images made possible by these and other later advances in photographic technology brought forth new forms of practise such as photojournalism and documentary photography in the 20th

century, and these would play their own distinct role in recording the history of the Bull Ring.

In the decades approaching and following the Second World War, press photographers working for the *Birmingham Post* often photographed the traders and crowds of shoppers that filled the streets of the Bull Ring. Though the Bull Ring itself appears increasingly shabby, the photographs from this era reflect the vitality of the place, and the sense of excitement and community spirit shared by shoppers and traders alike. For many, all that began to change when work to construct a new Inner Ring Road commenced in 1957, and a scheme to create 'the world's most advanced shopping centre' began a few years later. The war created a psychological desire for a fresh start and that coupled with undiluted confidence about the ability to create a new kind of urban future drove forward the largest transformation of the city centre in Birmingham's history. Laing, the construction company responsible for building the new Bull Ring Centre, employed staff photographers throughout the project to chart progress across the 23 acre site. They were joined by photographers from the City's Public Works Department, with each recording the construction of the shopping malls, piazzas and bridge that connected the sites across the Ring Road. Birmingham's two main newspapers also sent their staff photographers to capture the sense of excitement and civic pride embodied in the creation of this modern, cosmopolitan development. They used a variety of devices such as aerial photography to impress upon readers the sheer scale of the project; views of key buildings such as the car park in Edgbaston Street, were shot from low vantage points to create images imbued with a sense of dynamism and modernism, and editors created

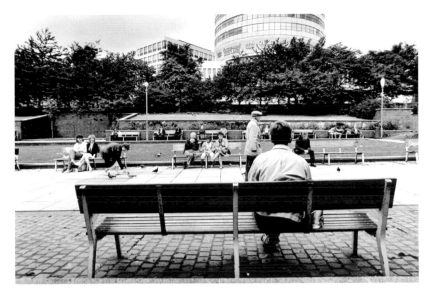

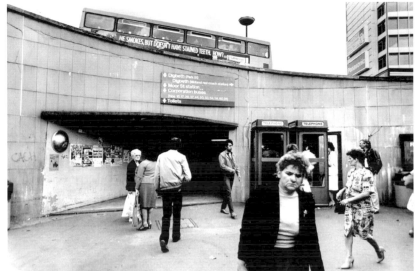

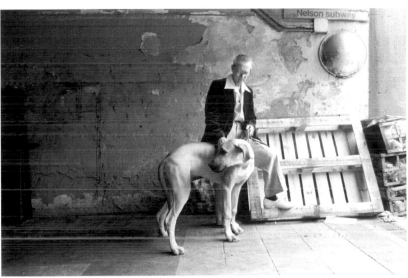

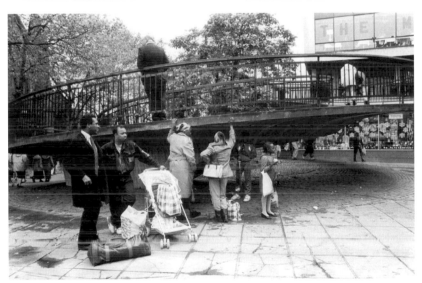

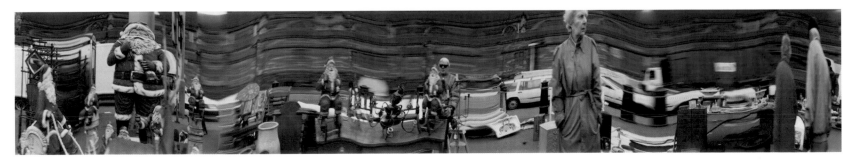

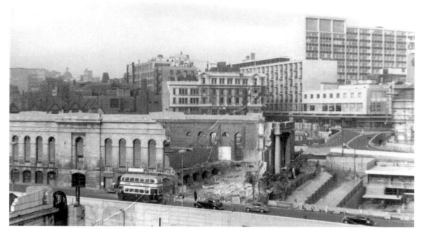

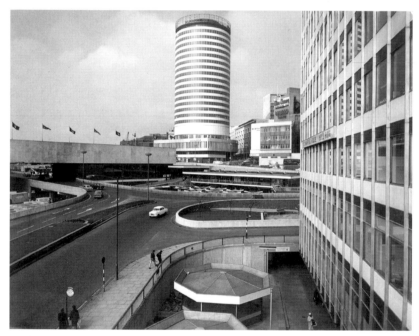

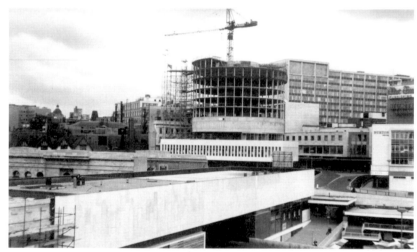

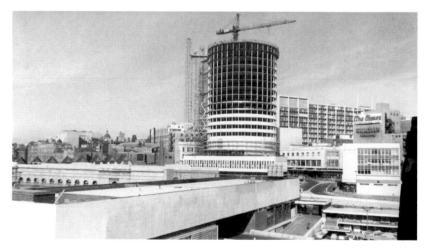

(Clockwise from top left) *Royal Visit to the Bull Ring*, Post & Mail Studios, May 23, 1963; *Construction of the Rotunda*, Derek Fairbrother, part of a series between 1961 and 1967; *Bull Ring*, photographer unknown, Post & Mail Studios, c. 1969. (Opposite) *Subway, Moor Street, Bull Ring*, Roy Peters, 1985.

(Overleaf) Photographs by Adrian Ensor of *Bullring*, 2002-2003.

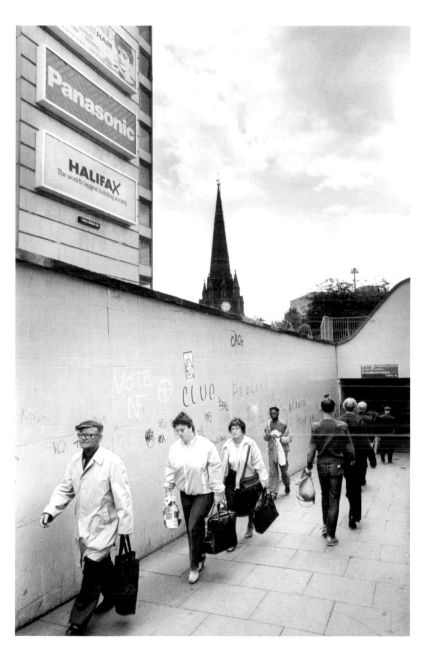

features juxtaposing images of the old and new Bull Ring to communicate the feeling of civic pride created with the new centre rising up from the rubble and ashes of the old. Laing's photographers were present alongside those of the local and national press at the opening ceremony on May 29, 1964, and they returned throughout the 1960s to record a series of special events promoting everything from potatoes to foreign holidays.

One building in the new Bull Ring Centre came to dominate the public's imagination and the skyline of Birmingham: The Rotunda. Derek Fairbrother, a local amateur photographer, set out to record the construction of The Rotunda, and having selected a vantage point, began taking a series of photographs at regular intervals on July 23, 1961. He completed his marathon task on March 26, 1967 and the resulting pictures provide a unique time-lapse sequence as the 25-storey, 265-foot building soared above the Bull Ring. The Rotunda came to symbolise the new Birmingham of the 1960s, gaining first iconic and more recently listed status. Over the last forty years photographers ranging from George Rodger to Matthew Murray have sought to immortalise its unique place, both physical and metaphorical, in the city.

Shortly after it opened, the Bull Ring redevelopment of the 1960s came under serious criticism and by the early 1980s it had become a notorious symbol of bad planning. Whereas the photographs of the early 1960s spoke all about the triumph of the modern city, those of the 1970s and 1980s all spoke a very different language. Independent documentary photographers like Roy Peters began making images which questioned and

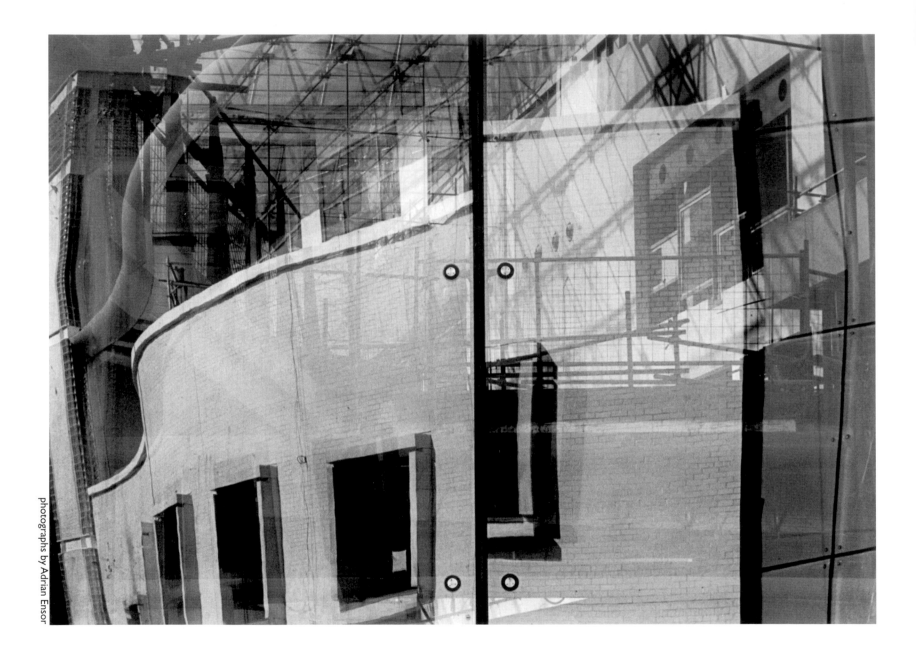

photographs by Adrian Ensor

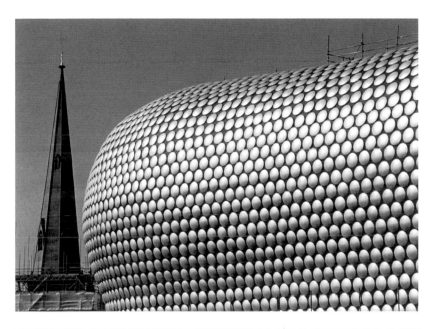
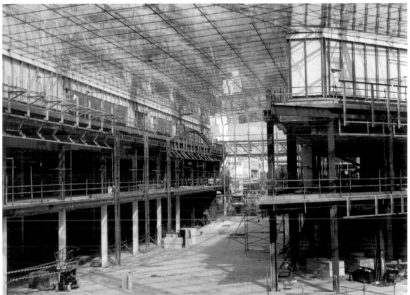
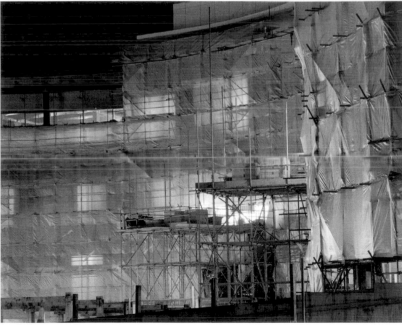
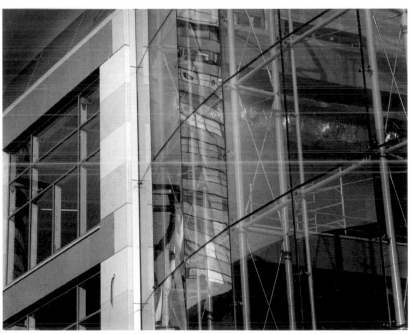

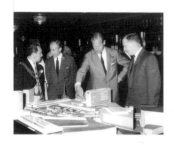

John Hirst, architect, explaining the model of the Bull Ring to Prince Phillip, Laing & Co., 1963; *Potato Marketing Board's promotion, 'Potatoes in Summertime', c.* 1967, Laing & Sons.

criticised the assumptions and plans of the previous generation, and spoke graphically about the way in which the Inner Ring Road had seemingly crashed through the site, separating the church and the market from the rest of the city; how pedestrians had been driven into dark, unattractive subways, and through a labyrinth of passages and escalators to navigate their way through the shopping centre; and how the developers had rammed together four levels of shopping, a market hall, a multi-storey car park, an office block, a bus station and a banqueting hall into one vast inhuman concrete complex. These and other photographs formed part of a seminal exhibition, *Imagining the City* (1986) which sought to question the redevelopment of the city between 1941 and 1971. Peters' photograph of Manzoni Gardens for example comments on the paradox of the presence of this green public space in the heart of an industrial city, where people could take a break from shopping and inhale the mixture of fresh air and car fumes from the nearby Inner Ring Road.

By 1989 the Bull Ring was being described as an 'infamous and exhausted retail hub', 'an eyesore' and 'a monument to the excesses of 1960s town planners'. The first of a series of plans for a new scheme were unveiled that included the demolition of the The Rotunda. Prompted by the coming wind of change in the same year photographer, Bob Kauders, oral historian Carol Gordon, and Theresa Sweeney, a member of the Bull Ring Preservation Committee, initiated an ambitious project, The Bull Ring Archives, to make a photographic and oral history of the Bull Ring. They set out make a record prior to the start of the phased demolition of the markets and shopping centre proposed by the London and Edinburgh Trust. Using a medium format camera, Kauders began to make a record in

which people would form the core narrative. The project ran into financial problems and was forced to close before the completion of the project.

As the debates about what kind of development should replace the 1960s model rolled on, a variety of photographers continued to record the human and physical dimensions of the Bull Ring. In 1990 Neville Thompson, then a member of the Small Heath-based community photography project, Wide Angle, undertook an extensive project which sought to capture the hustle and bustle of the market, and made a series of contrasting images of the quieter moments experienced by couples and individuals that took place in moments seemingly frozen from the hectic flux of events going on all around. Photographers like Dan Burn-Forti also travelled to Birmingham to record the 'gargantua of the baby-boom years' for a photo-essay, 'Elegy to the Bull Ring', published in *The Observer* in 1995.

In 1997 after seven years of bitter wrangling over its future, a new era in the history of the Bull Ring dawned when The Birmingham Alliance began work on a £500 million scheme to transform the area. Many of the press photographs taken during the course of this massive project seem to follow a pattern established in the Bull Ring of the 1960s; old buildings and facilities falling into a state of disrepair, planners and developers posing in front of models, demolition, rebuilding and grand opening ceremonies etc. However, the new Bull Ring has sparked off a host of creative photography projects, some of which have been initiated or supported by the Alliance itself. The first of these commissions was given to local photographer Luke Unsworth, who adopted an approach firmly rooted in the traditions of reportage photography. Unsworth has been

working to 'tell the story' of the development of the Bull Ring through monochromatic images until its completion in 2003. His approach to forming a creative narrative around this project is to physically get in amongst the changes to document both the physical and social landscape of the area. In particular Unsworth has chosen to focus on the human dimension of this story, and to record the people who the changes most directly affect – the traders and shoppers who have been the backbone of the Bull Ring for generations gone by.

A completely different approach to the same subject has been adopted by Michael Hallett. Initially using a combination of a digital camera and traditional film negatives, in 2001 Hallett began making a series of panoramic constructions of the redevelopment of the Bull Ring. Later his output became entirely digital. Hallett's image referenced the historical form of the photographic panorama and the more recent construction techniques of David Hockney's process of creating 'joiners'. However, instead of pasting together the physical objects themselves, Hallett rebuilt and reworked his images on computer to create a new master file. As the building work progressed, Hallett's approach to taking and re-working his images also altered. It began with simple five image, one hundred and eighty degree panoramas and evolved into three hundred and sixty degree panoramas and images made up from as many as fifty-seven separate images. Hallett eventually widened his remit capturing single images that complemented and extended the narrative of his constructed images. In addition to recording the construction work itself, Hallett also turned his camera to the spectacle of consumerism that was and still remains at the heart of the Bull Ring.

Hallett's adoption of the panoramic format and composite imaging is an attempt to expand the conventional cameras' limited field of view. Other photographers working in the city have found different ways of expanding the camera's vision without such interventions and manipulation. In 2001 the acclaimed landscape photographer, John Davies was commissioned by the Alliance to record the last days of the demolition process, and chose to photograph the city from raised viewpoints. Davies' large prints and chosen position allows the viewer a privileged viewpoint at this critical moment in the history of the project. Like Davies' photographs, Adrian Ensor's images contain virtually no humans at all. Commissioned by the Alliance to record the final twelve months of the project, Ensor focused on the architecture of the site, but did not seek to create architectural photographs in the conventional sense. He focuses on sections of buildings and the semi-abstract reflections of the site mirrored in the vast spans of glass which create the walls and windows of shopping malls and buildings. Through these images Ensor expresses personal and artistic responses created by the building, rather than documenting the edifice in the traditional manner.

In time, no doubt, these and all the other photographs described here may be viewed by future generations who may themselves witness the next redevelopment of the Bull Ring.

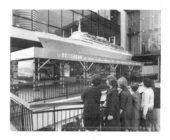

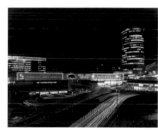

Giant model of the SS Rotterdam, Holland-America Line, on the eastern terrace, c. 1975, Laing & Co.; The Bull Ring and Rotunda at night, c. 1969, Gerhard P. G. Schienke.

CHANGING FACES

Luke Unsworth's documentary essay *Changing Faces* started as a personal project to record St Martin's Market before the development of the Bull Ring. The project grew to encompass the entire Bull Ring and covers the period between 1999 and 2002.

photographs by Luke Unsworth

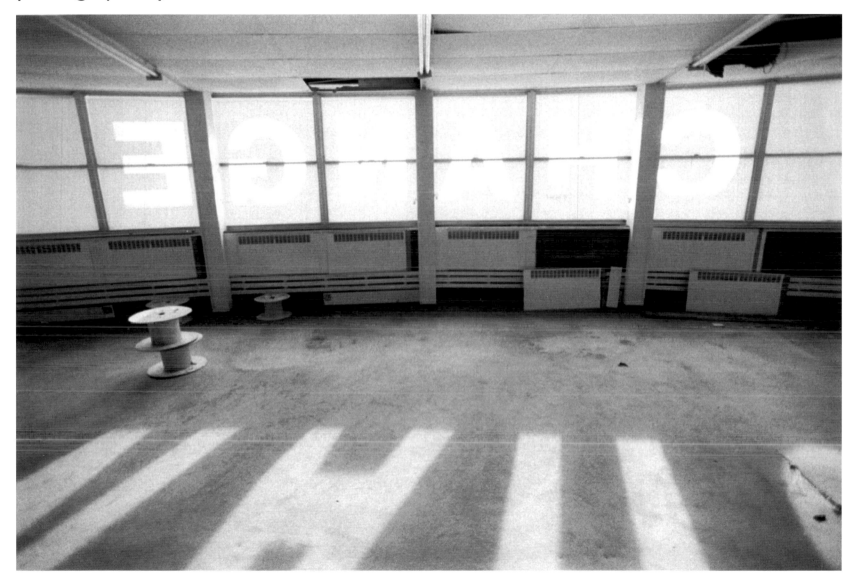

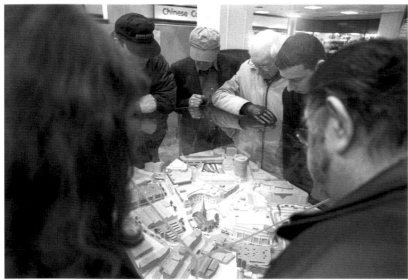

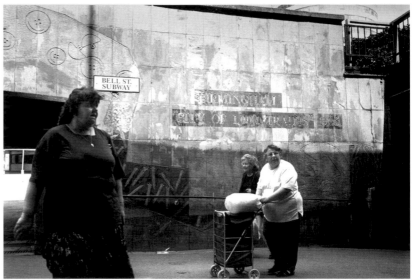

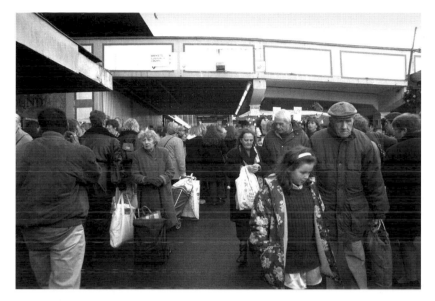
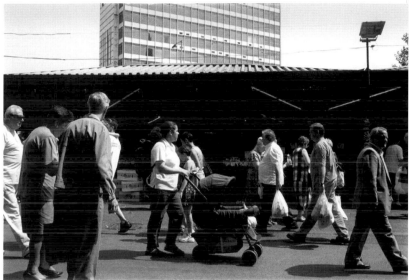
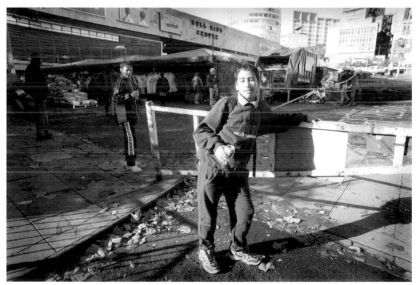
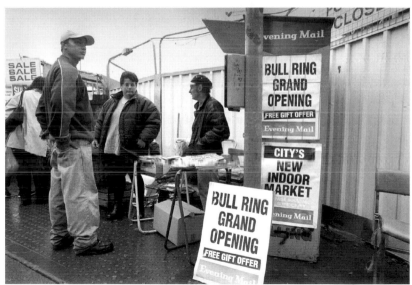

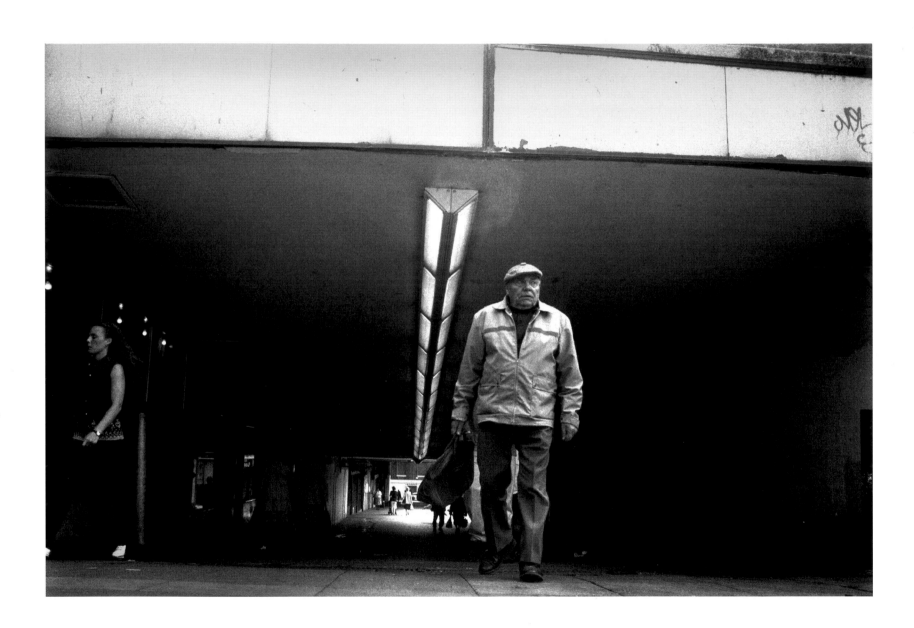

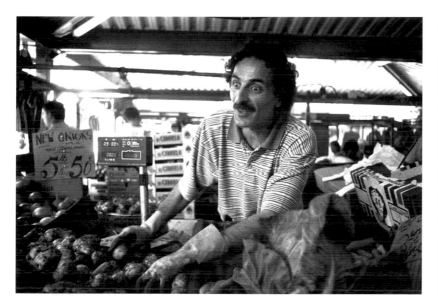

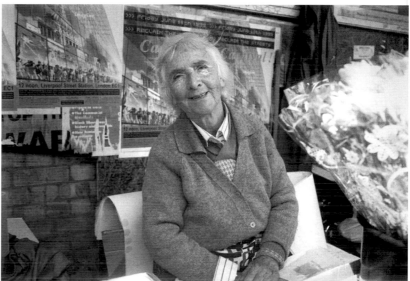

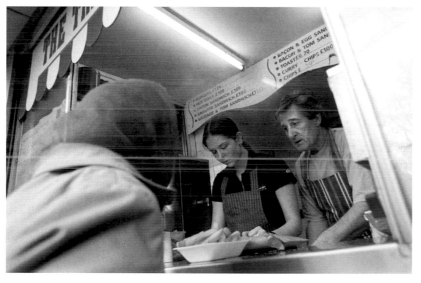

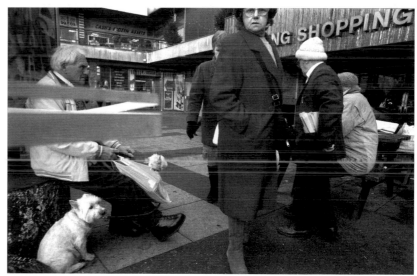

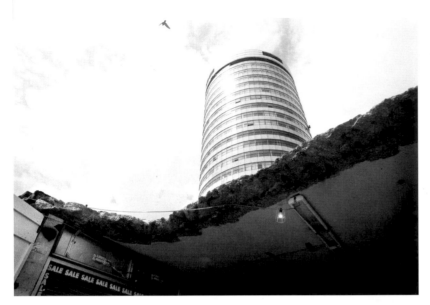
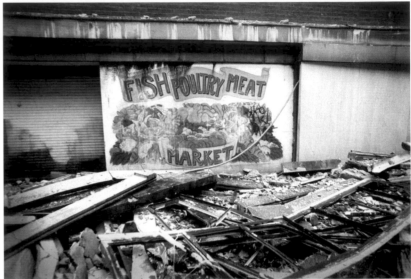

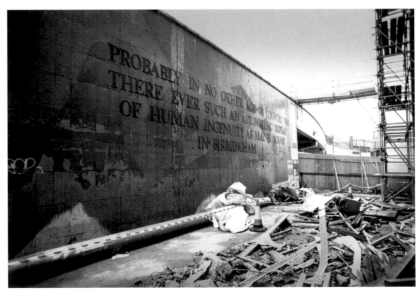

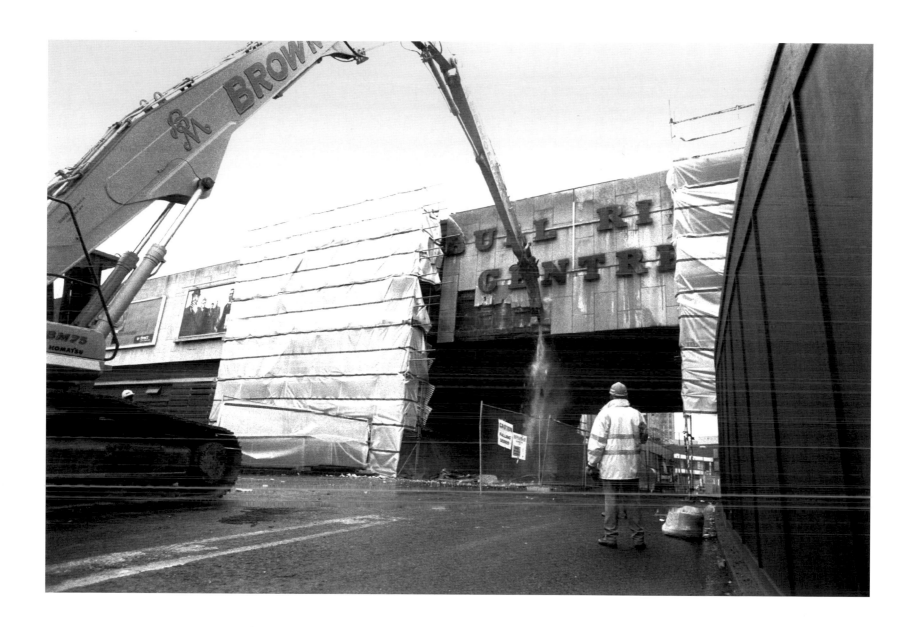

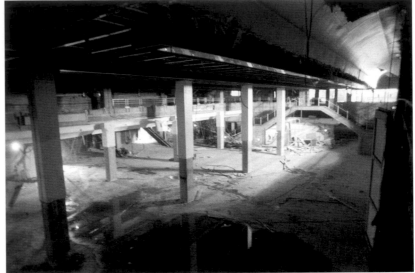

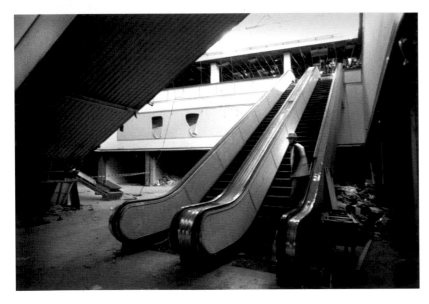

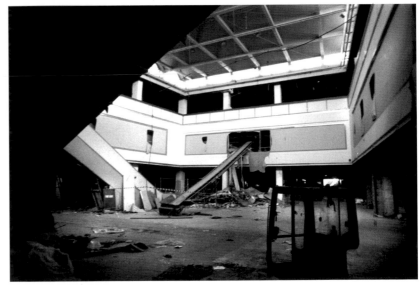

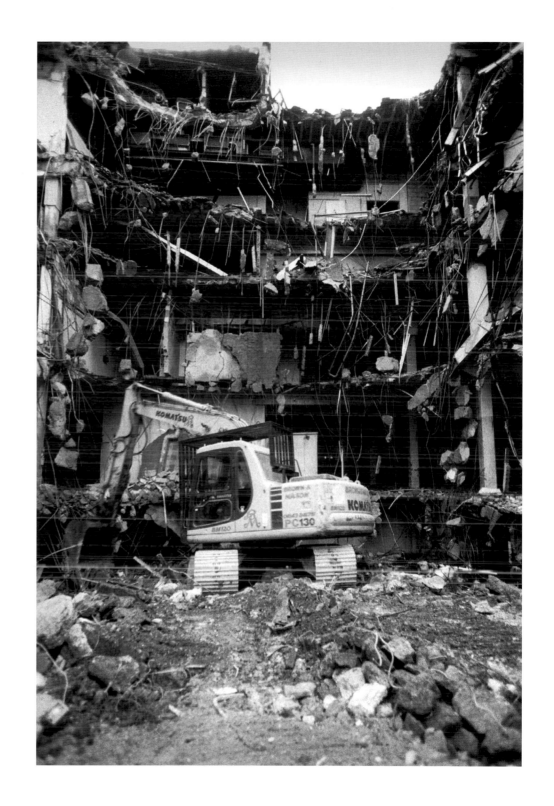

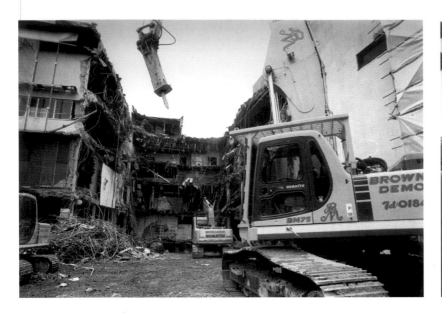

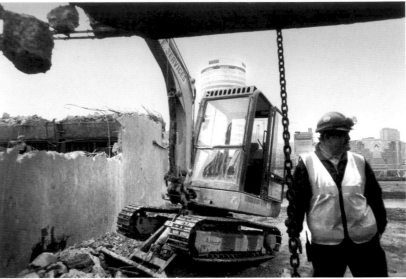

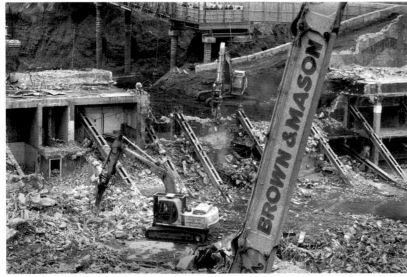

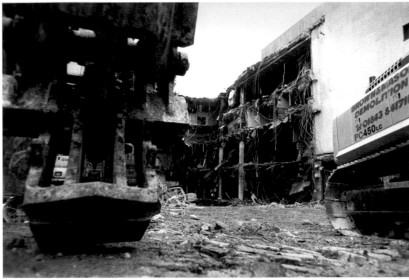

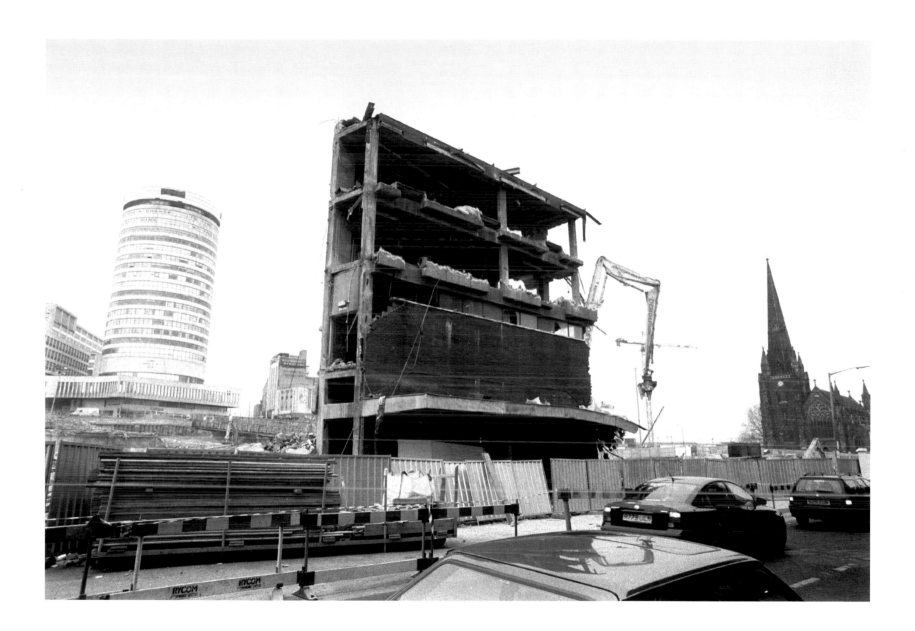

OUT OF THE GROUND

Nothing can succeed without a guiding vision. But a vision is not enough without commitment and the skill to deliver it. Bullring has all of those things and will be a landmark in the transformation of Birmingham.

The city's councillors gave the lead with their foresight in setting out a strategy for the city. There is already ample evidence of the realisation of their plan. Bullring, the gateway into 'Eastside' marks the next chapter in Birmingham's exciting contemporary story.

Opportunities arising from visions have to be seen and grasped. The Birmingham Alliance did just that. The Alliance is a partnership between Hammerson plc, Henderson Global Investors Ltd and Land Securities plc. Delivering the Bullring project made sense for them and for the city.

Such a key city site needed to have a truly captivating appearance and a stature to match its history and its future. The responsibility to achieve these prerequisites and to design Bullring went to Benoy, architects with a reputation for experience and imagination. As the new architecture has unfolded into view, the strength and beauty of their ideas and designs have become realities.

The site itself became a subject of fascination and a landmark. This book evidences that and enables the story to be relived time and time again. There was the network of tower cranes that went up and came down! The four massive curved steel trusses not only suspend the northern end of the site above the tracks into New Street Station but are sculptural features in the new cityscape.

To build what the architects and developers envisaged called for a depth of imagination, ability, skill and sheer hard graft. Teams of the highest quality consultants were employed to ensure understanding, interpretation and delivery. These included such prestigious firms as Ove Arup, Balfour Beatty, Gardiner & Theobald, and Waterman Partnership Holdings plc. The main contractor was Sir Robert McAlpine, employing over 200 firms during the construction. Their combined teams were the ones who 'really made it happen on the ground'. In turn, whole armies of specialists, too numerous to mention by name here, have added the engineering, the technology and the detail, without which, Bullring could not spring into life.

One of the highlights of the construction has been the emergence of Selfridges' store, designed by Future Systems and inspired by the 1960s chain mail dress designs by Paco Rabanne. First there were its fluid lines, then its protective garment, mimicking its amazing coat of spun aluminium disks, distinctive in their Yves Klein blue and silver.

Public spaces to admire and to enjoy are major features of Bullring. Landscape architect Gross Max have designed the most important, St Martin's Square and the central pedestrian boulevard, St Martin's Walk, opening up a view of the refurbished church, lost for too long in the previous Bull Ring and diminished by years of city grime.

Art has been a high priority and top artists have been commissioned to create major works that contribute to the project and to the city. The results include a dramatic three-dimensional light and water sculpture, a twice life-size bronze bull by Laurence Broderick and a stunning high level glass art work at the New Street entrance by Martin Donlin.

The men and women of the teams that envisaged, designed and built Bullring have much of which to be proud. The results of their dedication and hard work will be central to life in Birmingham for many years to come.

Gil Gillis

photographs and panoramic constructions by Michael Hallett

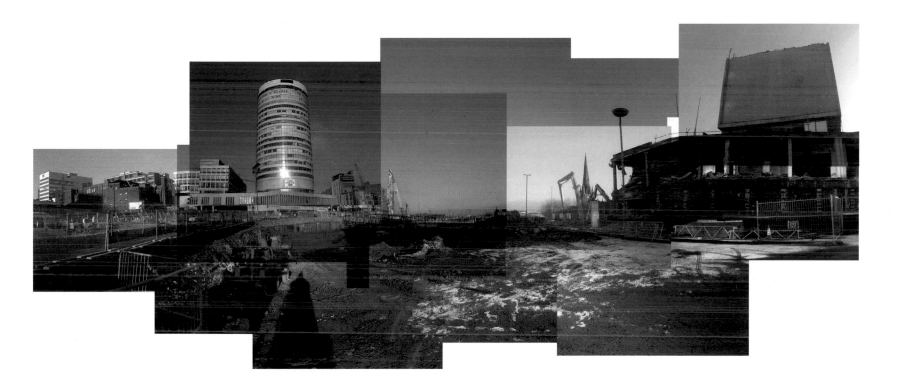

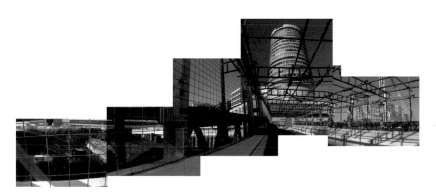

The first of the Bull Ring panoramic constructions taken on January 14, 2001. 'Time for a change' shows the Rotunda and the hole in the ground where the Bull Ring once stood. (Left) The walkway across the site looking towards the Rotunda.

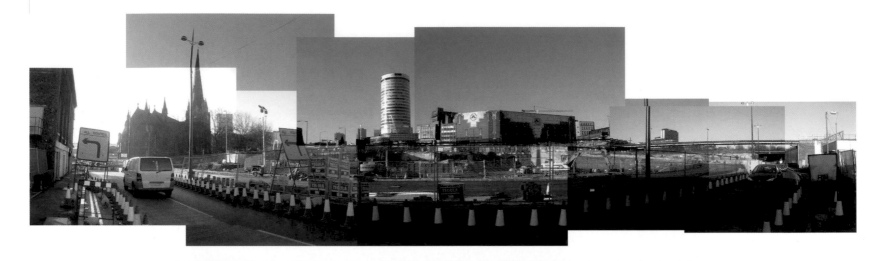

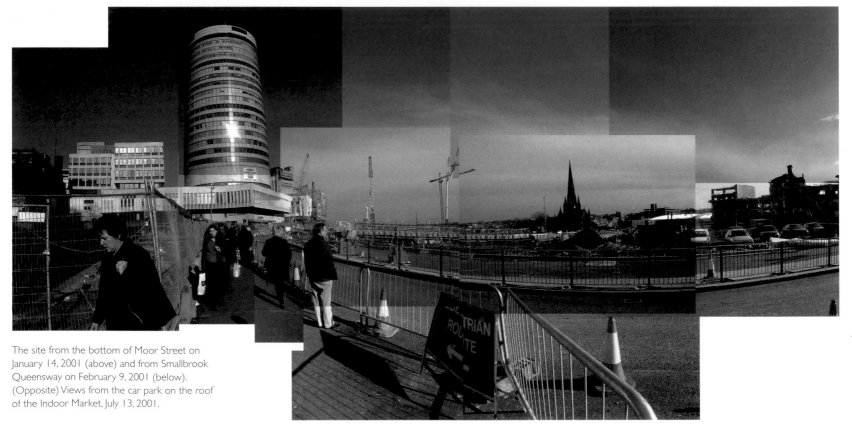

The site from the bottom of Moor Street on
January 14, 2001 (above) and from Smallbrook
Queensway on February 9, 2001 (below).
(Opposite) Views from the car park on the roof
of the Indoor Market, July 13, 2001.

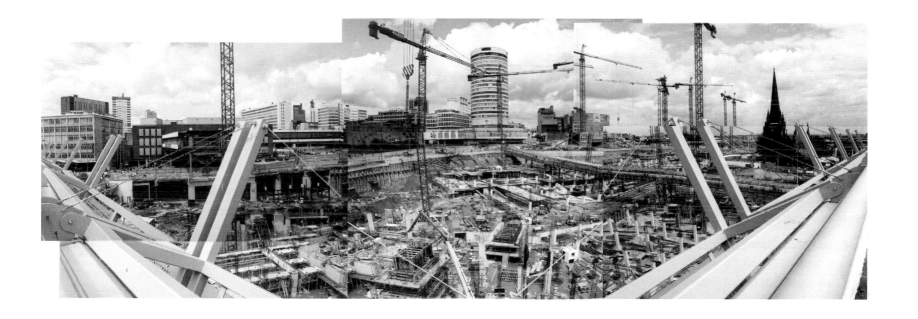

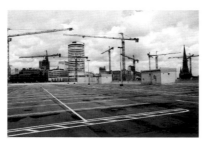
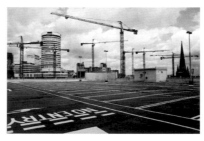

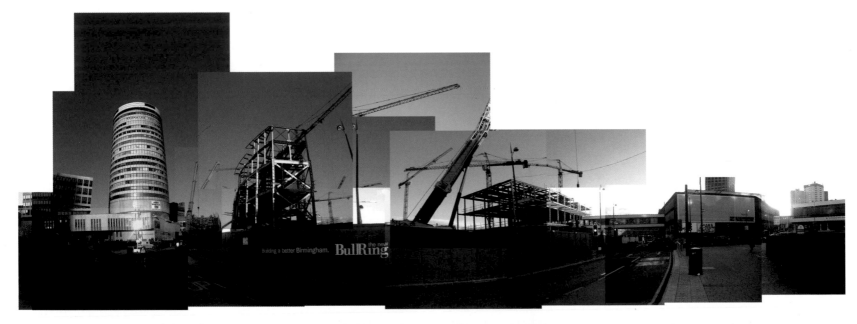

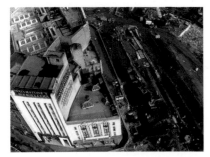

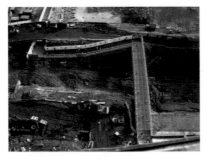

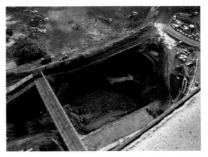

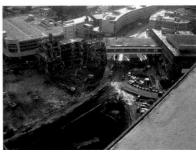

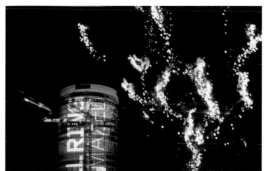

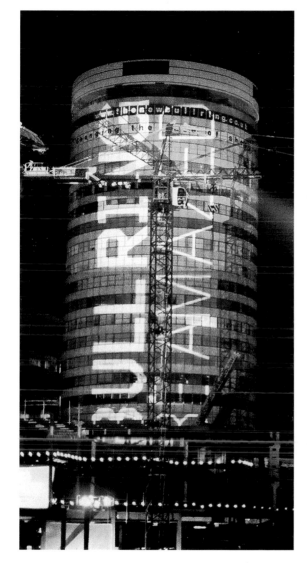

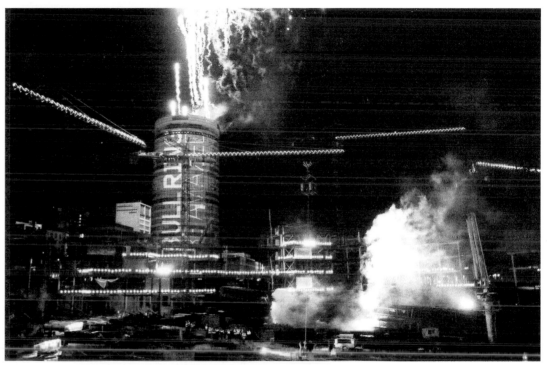

(Opposite) From Smallbrook Queensway, November 8, 2001; small images from top of Rotunda.
(This page) Light, fireworks and dancing cranes, November 8, 2001.

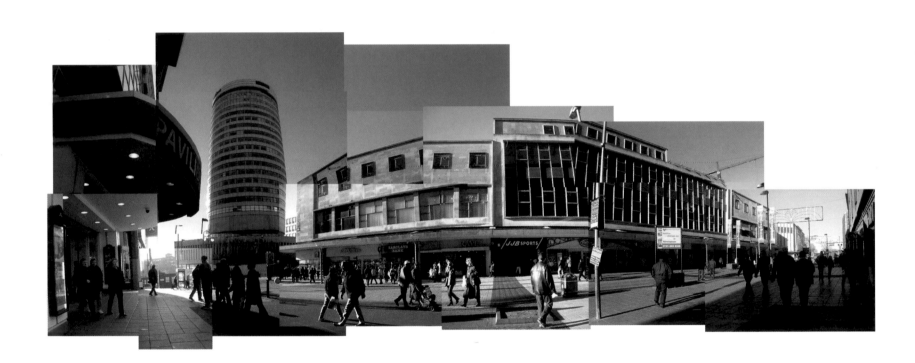

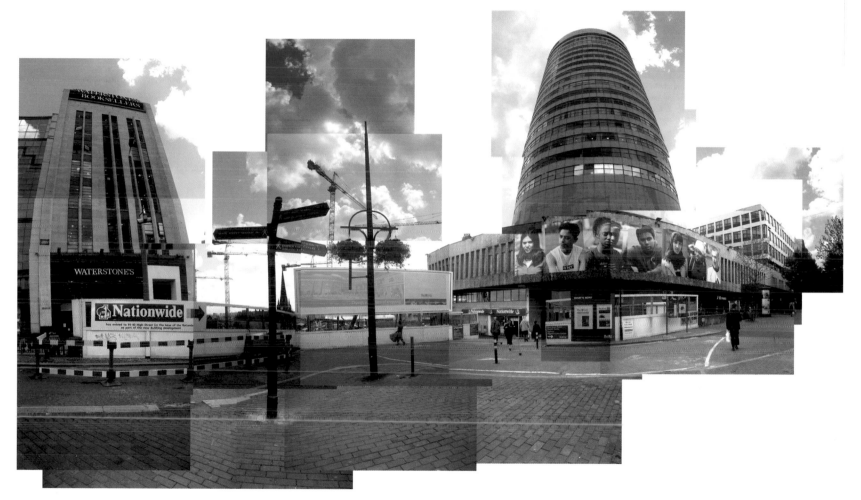

Constructions from the High Street.
(opposite) January 14, 2001 and (this page)
July 16, 2001

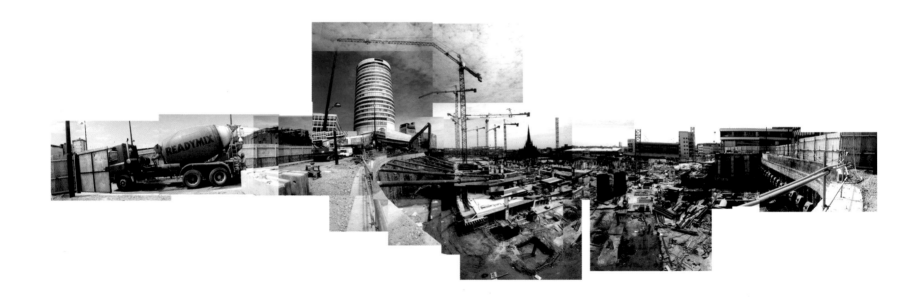

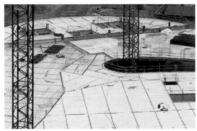
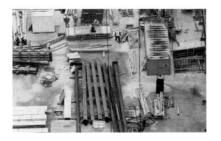

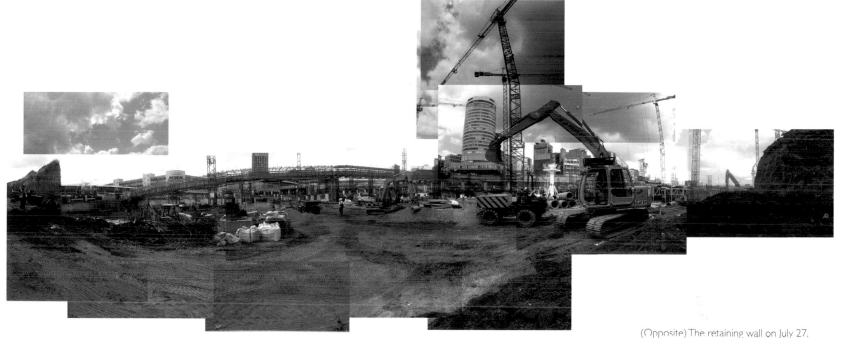

(Opposite) The retaining wall on July 27, 2001. The first 360 degree panorama consisting of 35 single images.
(This page) On site from near St Martin's Church, July 16, 2001. Black and white images show details viewed from top of the Rotunda.

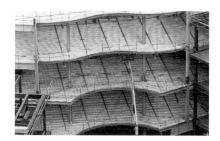
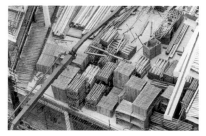
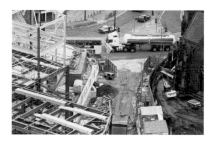
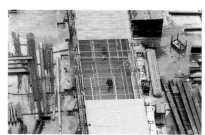

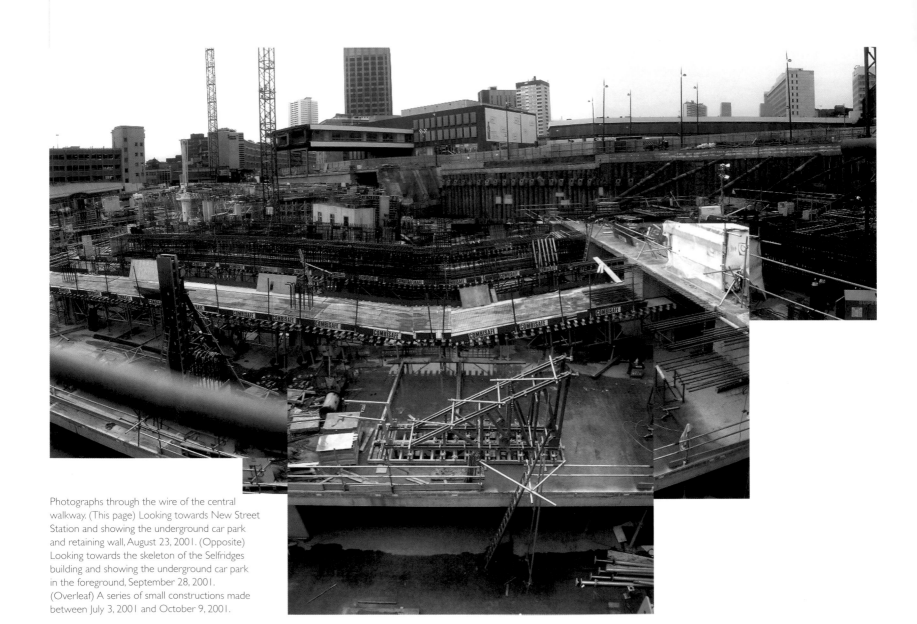

Photographs through the wire of the central walkway. (This page) Looking towards New Street Station and showing the underground car park and retaining wall, August 23, 2001. (Opposite) Looking towards the skeleton of the Selfridges building and showing the underground car park in the foreground, September 28, 2001. (Overleaf) A series of small constructions made between July 3, 2001 and October 9, 2001.

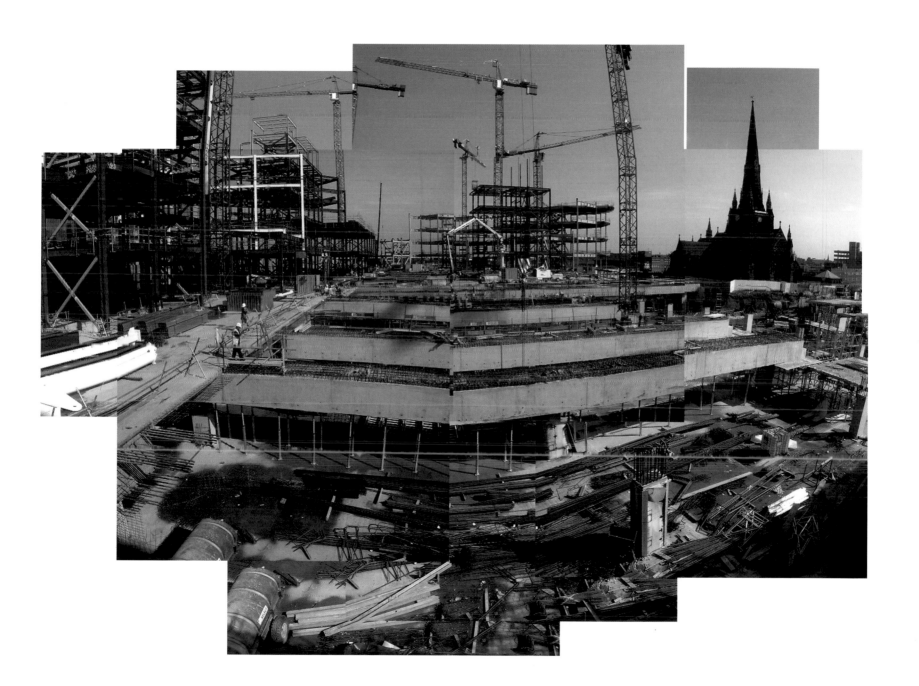

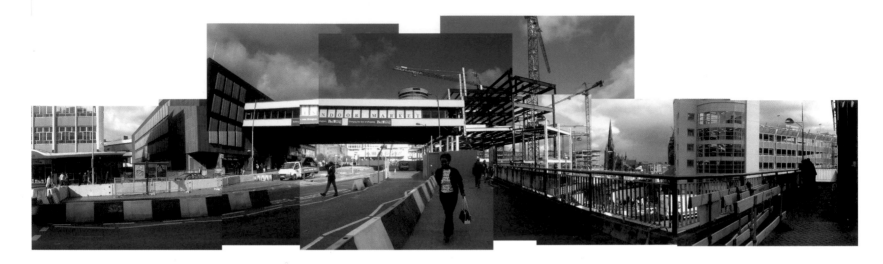

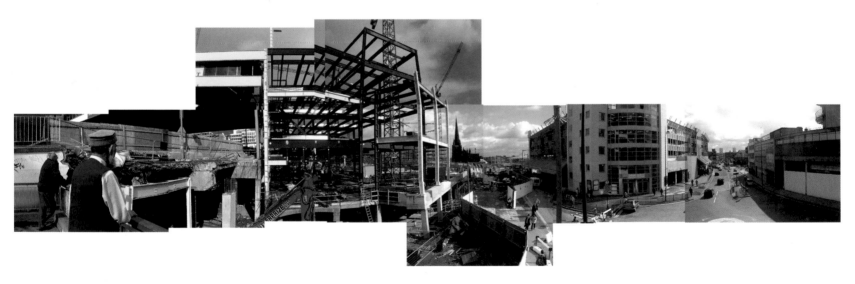

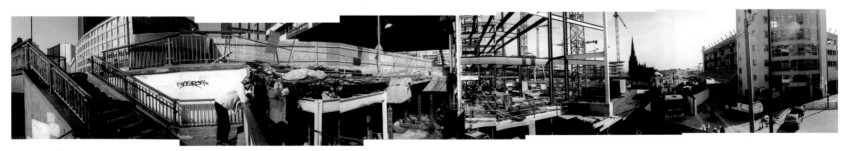

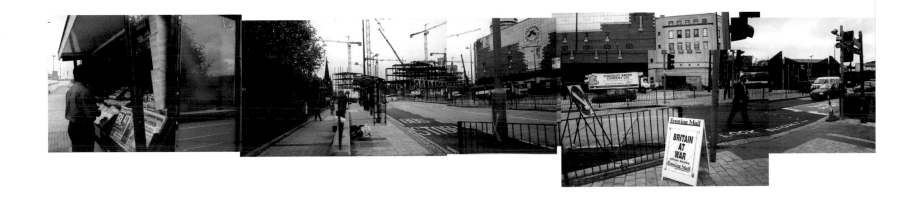

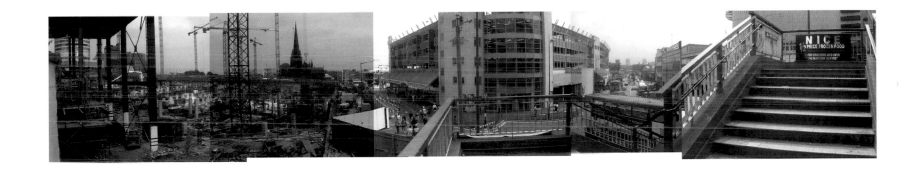

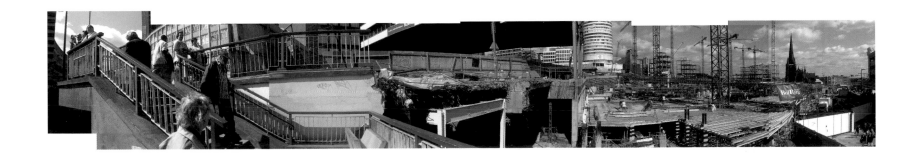

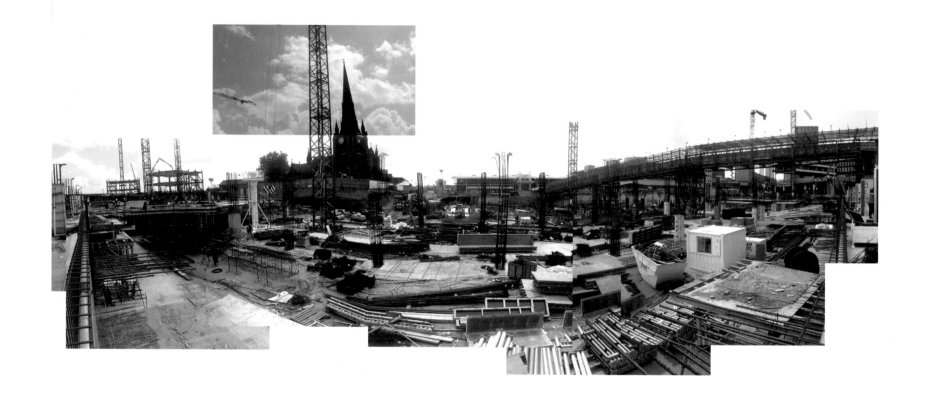

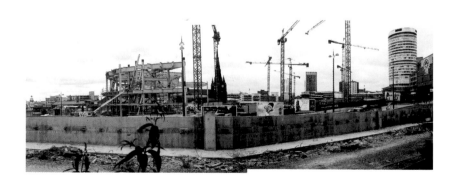

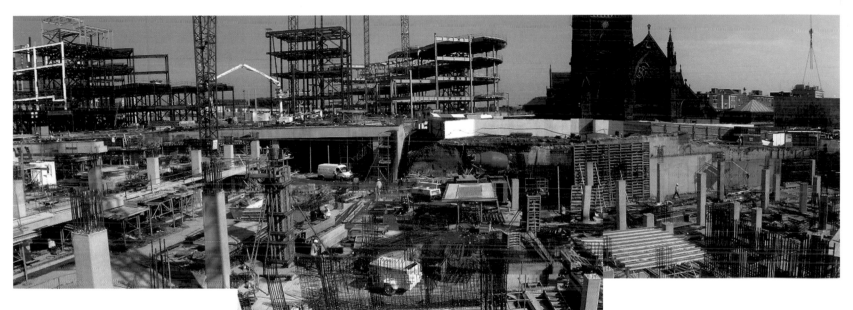

(Opposite) On site panorama taken from the second floor of the underground car park showing the walkway to the right of the image, July 16, 2001. Inset shows a view of the Selfridges building from a platform of Moor Street station. (This page) Looking towards St Martin's Church from a pedestrian walkway, September 28, 2001.

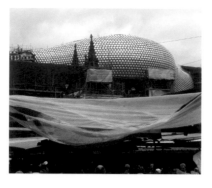

THE MARKETS

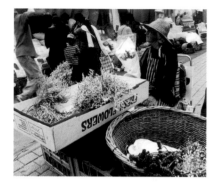
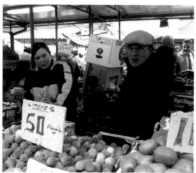

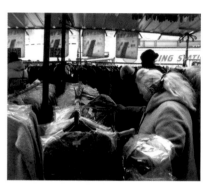

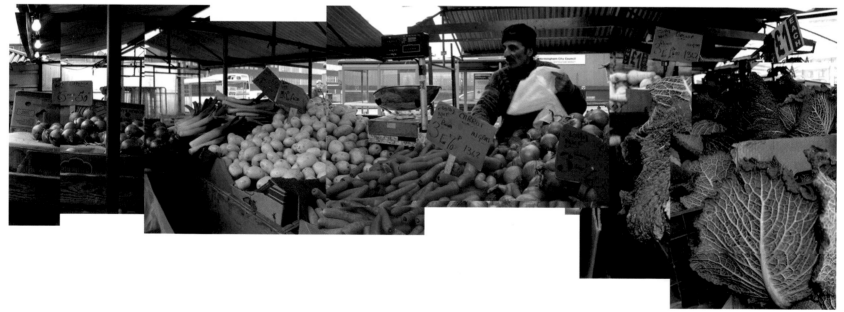

photographs by Michael Hallett

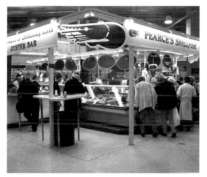

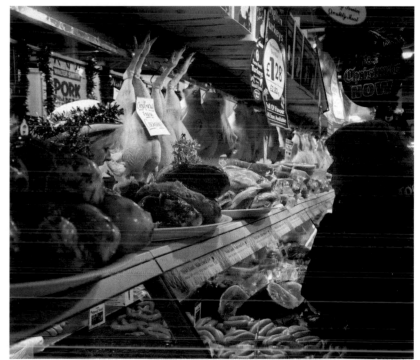

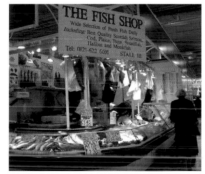

(Opposite) The outdoor market recorded mainly in the week before it moved to its new site in March 2003. (This page) The new indoor market photographed over a period of time but mainly just before Christmas 2002.

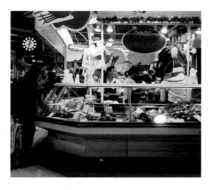

RISING INTO THE AIR

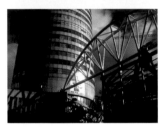

The story and scale of Bullring evokes a range of questions. This factfile provides some of the answers:

Early history
There is evidence of a 12th century 4m wide boundary ditch and of trading facilities.
There is evidence of town planning in the 13th and 14th centuries with housing for market traders.
There was an abundance of wells for industrial, domestic and communal use.

The footprint
Bullring is a 26-acre site; the size of around seventeen football pitches. 110,000 sq m development.
The site slopes 18m from the Rotunda to St Martin's Church.

The buildings
The 'Skyplane' roof covers 7,765 sq m in a virtually invisible suspended covering to give an impression of open streets.
There are 130 shops, cafés and restaurants.
The new Moor Street car park incorporates heritage sites; Banana Warehouse (the Edwardian former station goods depot) and some of the earliest concrete arches designed by French architect Hennebique, from 1903.

The materials
All the bricks used in Bullring placed end to end would stretch from Birmingham to Kingston upon Hull and all the blocks to Lands' End.
There is enough concrete in Bullring to stretch between Birmingham and Oban in Scotland ten times.

15,500 tonnes of steel have been used in Bullring; equivalent to 25% of the steel in New York's Empire State Building.

Street names
Swan Passage next to St Martin's Queensway derives from Swan Alley, a name appearing on a plan of 1731.
Names to reappear will be Jamaica Row and Spiceal Street. They first appeared on plans in 1795.

The retail environment
There are two department stores with a total floor space of over 41,400 sq m as well as 16 major shop units and 114 shop, restaurant and café units.
8,000 jobs have been created in Bullring. The partners in managing the job creation process with The Birmingham Alliance have included: Job Centre Plus; Birmingham & Solihull Learning & Skills Council; Birmingham City Council; and Pertemps Employment Alliance.
The Indoor Market covers 4,500 sq m and houses 90 traders.
It is estimated that 30 million shoppers will visit Bullring annually.
There are 3,000 car parking spaces for Bullring; 900 at the Indoor Market, 1,000 below Bullring and 1,100 adjacent to Bullring at Moor Street car park.
There is direct access from New Street and Moor Street stations, dedicated taxi rank, coach stop and push-bike parking area as well as service by many local bus routes.
The design of Bullring has incorporated improved access for the less able with gentle slopes, Shopmobility and other facilities.

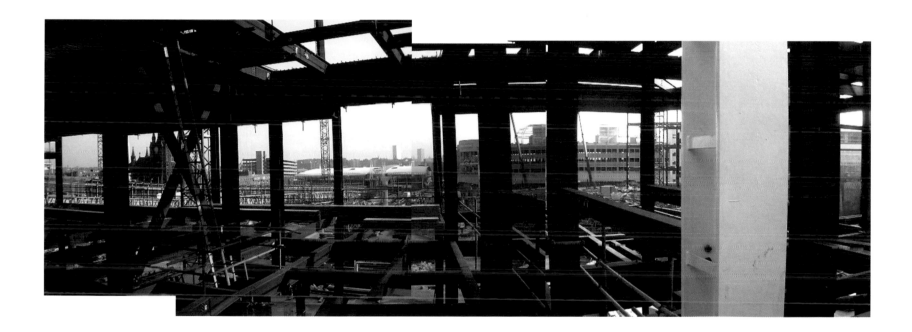

Looking towards the markets from
the top of the pedestrian walkway, October
30, 2001

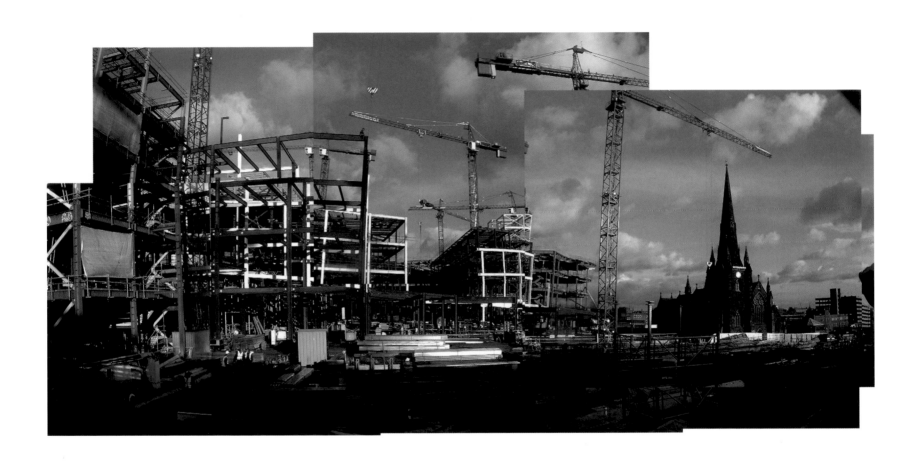

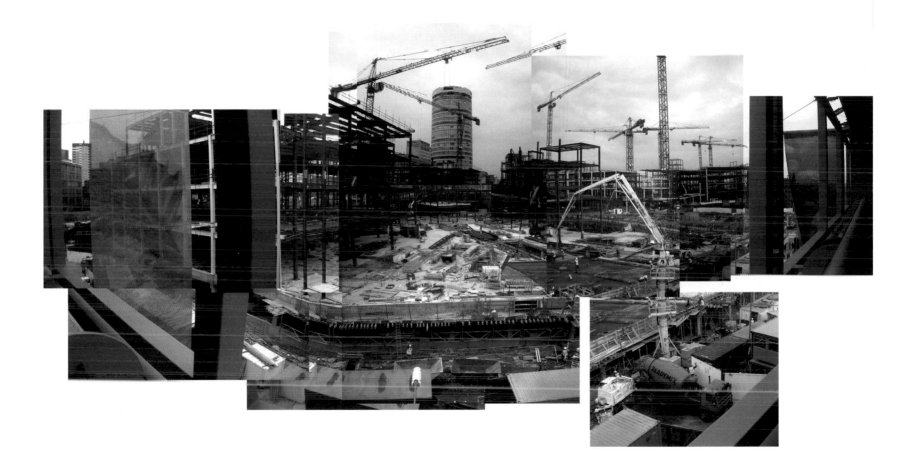

(Opposite) View from the central pedestrian
walkway, November 8, 2001.
(This page) Looking towards the Rotunda
from the market car park, November 20, 2001.

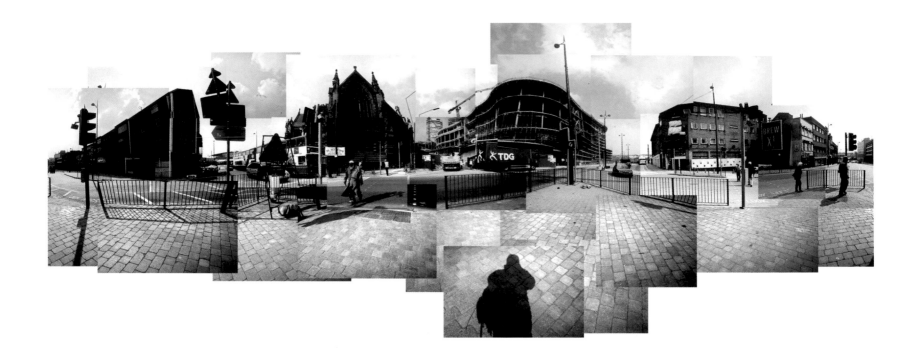

(This page) The Selfridges building and
St Martin's Church, April 10, 2002.
(Opposite) The Selfridges building, May 29,
2002. Inset view from Masshouse Circus
looking towards Bullring, May 29, 2002.

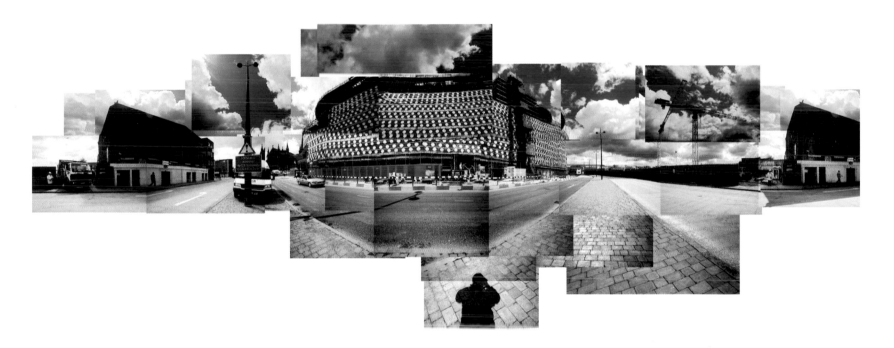

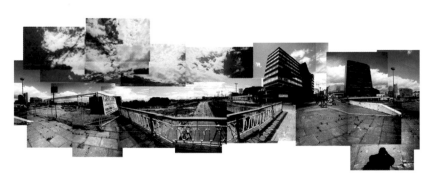

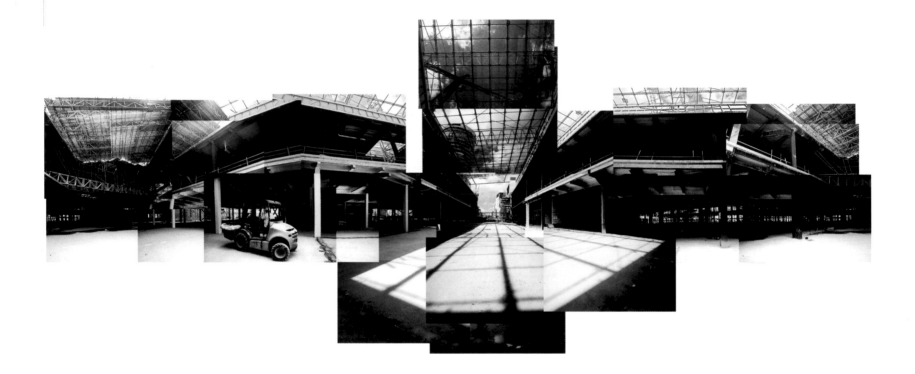

(This page) Interior of Bullring showing 'Skyplane' roof under construction, June 18, 2002. (Opposite) 360 degree panorama showing centre of site, June 18, 2002.

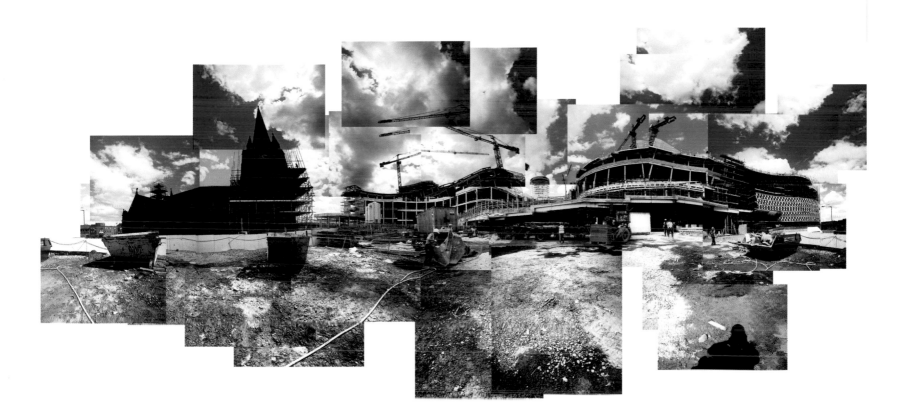

(Overleaf, left) Looking towards the Rotunda
from the central pedestrian walkway,
November 26, 2001; 360 degree panorama
from centre of site, October 30, 2001.
(Overleaf, right) The final pedestrian walkway
using the approximate footprint of St Martin's
Walk from the Rotunda to the church,
March 5, 2002; 360 degree panorama from
centre of site, February 12, 2002.

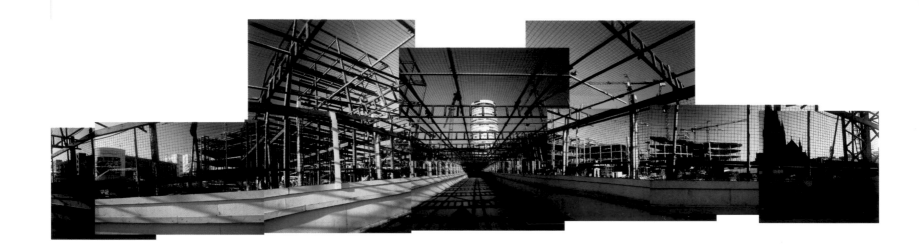

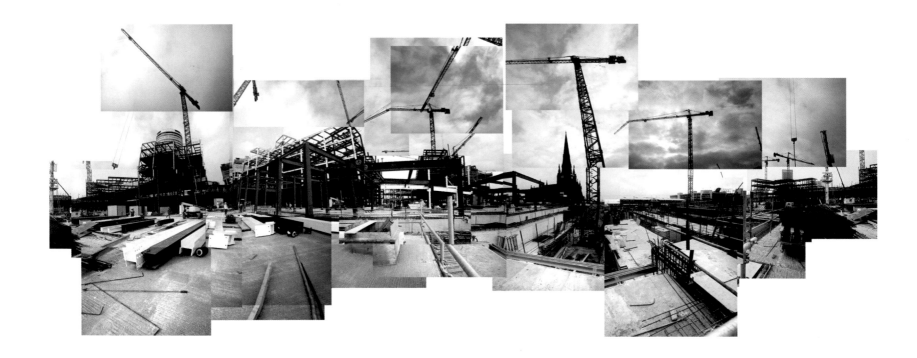

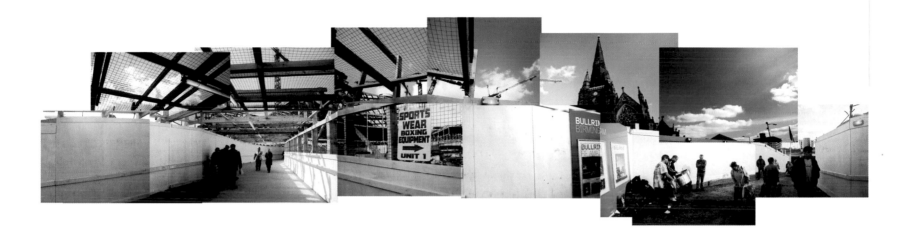

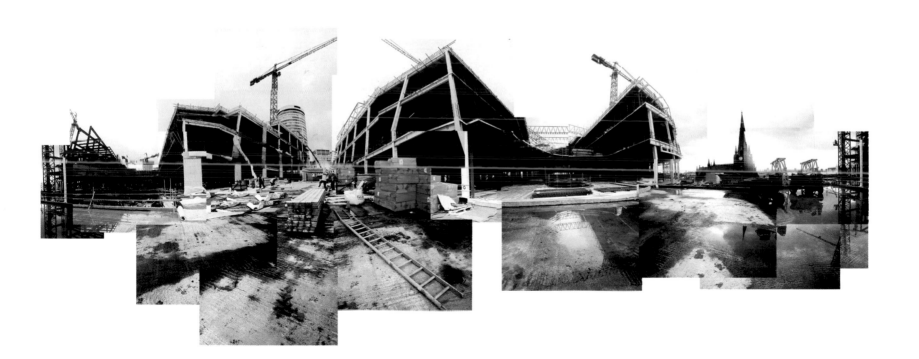

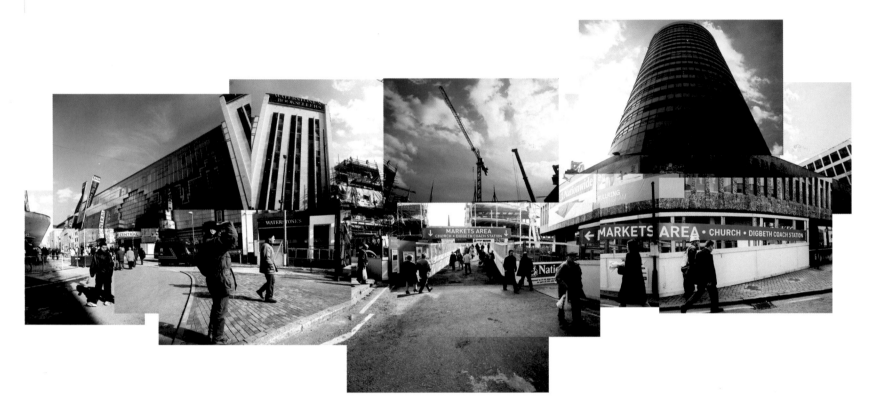

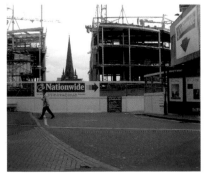

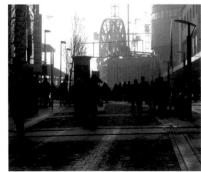

(This page) Bullring from the High Street,
March 5, 2002.
(Opposite) From the café with good honest
food. Looking towards Bullring from the
market area, March 22, 2002.

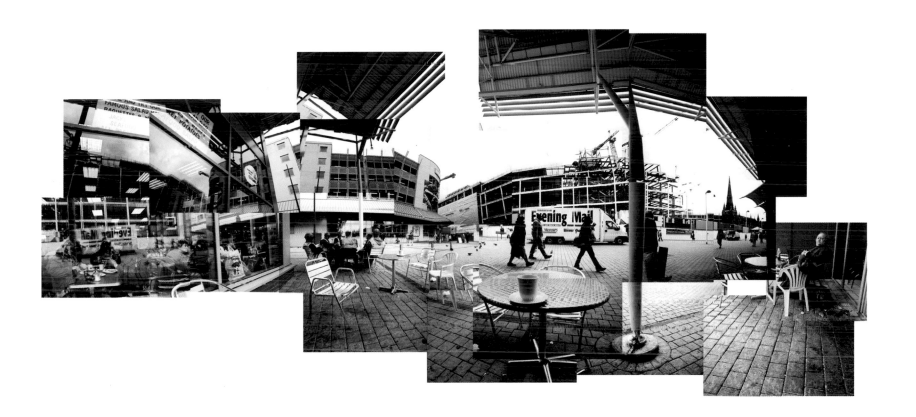

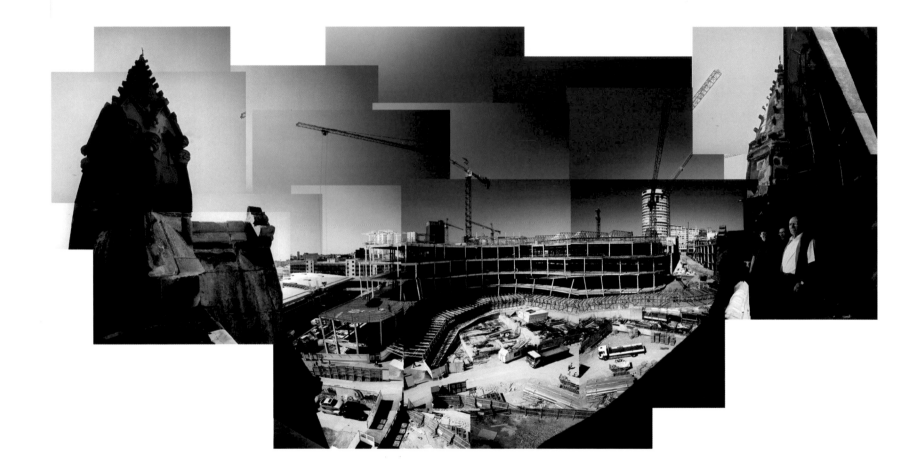

(This page) View from the base of the spire
of St Martin's Church, April 24, 2002.
(Opposite) Looking towards St Martin's
Church, June 18, 2002.

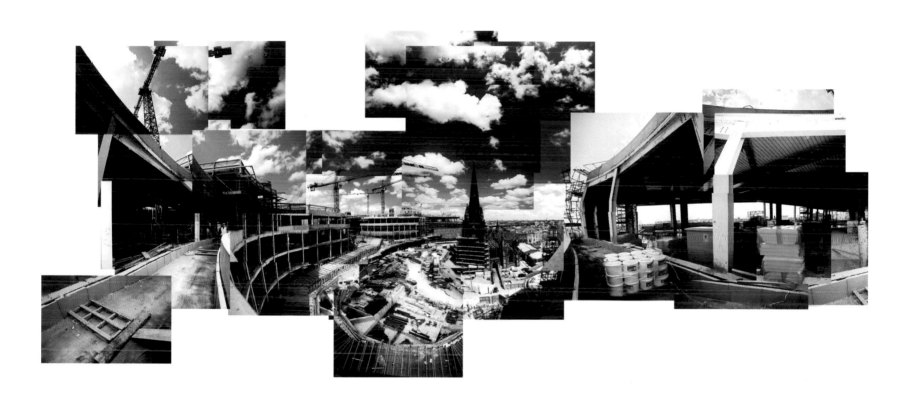

MOOR STREET STATION

The refurbishment of Moor Street's dormant Edwardian railway station alongside its existing two platform station, will provide the Bullring with a direct transport link to a key section of its catchment area. Chiltern Railways' new showcase station will initally run twice-hourly services along the M40 corridor to London Marylebone, stopping at wealthy commuter towns such as Solihull, Warwick, Leamington Spa, Banbury and High Wycombe.

 The Birmingham Alliance was contractually obliged by Birmingham City Council to restore Moor Street before Bullring opened, but only as a building not as a functioning railway station. Rather than meet the minimum requirements, a decision was made early on to spend the £6 million needed, (the project will cost £9 million in total), to turn the Grade II listed Edwardian building into a working station once again. Moor Street was originally opened by Great Western Railways in 1909 to ease congestion at neighbouring Snow Hill station, but has been derilect since 1986 with a new, two-platform station taking its place.

 Working in consultation with railway enthusiasts, original materials or exact copies are being used wherever possible, to replicate the original station's brickwork, colouring, signage, fixtures and fittings. For example, the entrance gates and a restored sign from Snow Hill station have been incorporated into the new design. Reproduction GWR lamps will light the concourse.

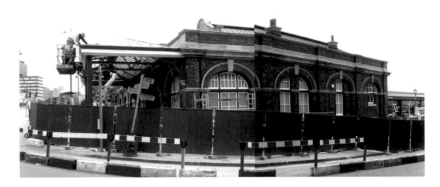

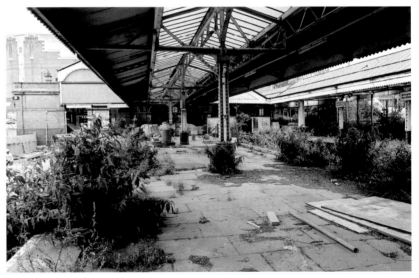

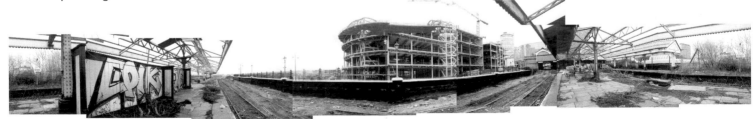

UNDER RESTORATION

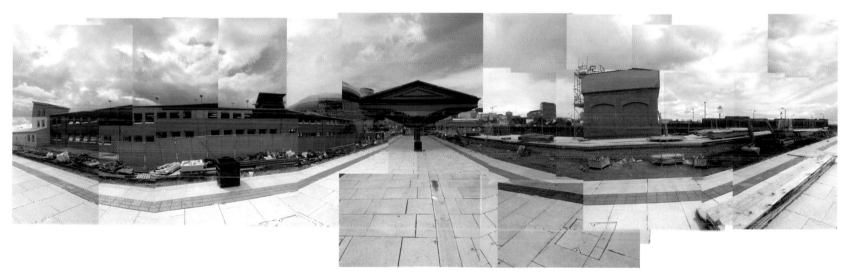

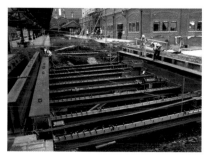

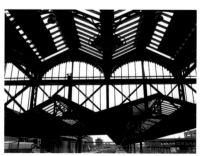

Black and white photographs show Moor Street Station before restoration, while all colour photographs show the station in an advanced stage of restoration.

COLOURING IN THE OUTLINE

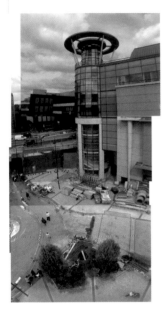

The Debenhams store at various stages in its construction. The panorama on this page shows Debenham's roofline looking towards the Rotunda, November 22, 2002 and on the facing page the building by the Indoor Market on December 4, 2002 and again on February 20, 2003.

One of the aims of the vision for Birmingham by the city councillors is to re-establish the city, not simply as 'Second City', but as a world class shopping and leisure destination.

Bullring, therefore, had to aspire to and emulate international status. To achieve this there had to be an understanding by everyone involved in the development that image is of paramount importance to those selling lifestyle branded concepts. The success of the marketing campaign by The Birmingham Alliance, based on selling the city with quality retail as a core ingredient, has had a remarkable effect. The internationally recognised facilities already established have played their part, too, in evidencing that Birmingham 'means what it says and gets things done'.

As a result, flagship stores have been attracted. For Debenhams, back in Birmingham after twenty years, their prestigious store is one of their largest outside London and the first in a new generation of 20TEN stores. Selfridges make their debut in the city in style. Many other well-known names are here and a number of retailers have planned their

trading debut or the launch of new concept flagship stores in Bullring. Shoppers will judge for themselves, but the retailers and restaurateurs have made their judgement and voted in favour of Bullring being a magnet attracting visitors and shoppers and of being a success.

Visitors will find an experience that draws on the best of the city's historic traditions. The dramatic 'Skyplane' roof floating almost unseen above Bullring ensures a relaxing stroll through the series of malls, open spaces, covered streets and public piazzas between the shops, cafes and restaurants. A retail frontage 'design guardian', Checkland Kindleysides (CK) was appointed to work with each retailer, encouraging creative store design concepts with focussed signage, shop fronts and window displays to build a unique Bullring experience. Bullring is set to become more than just a 'trip to the shops'.

Bullring will again be at the heart of Birmingham as of old – but refreshed and renewed for the next phase in its colourful story.

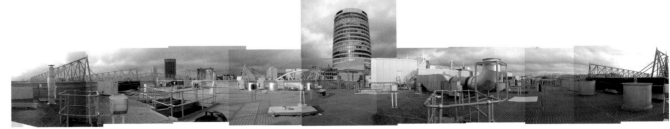

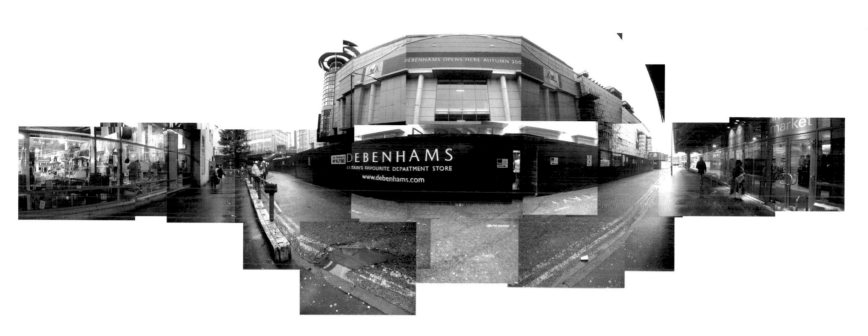

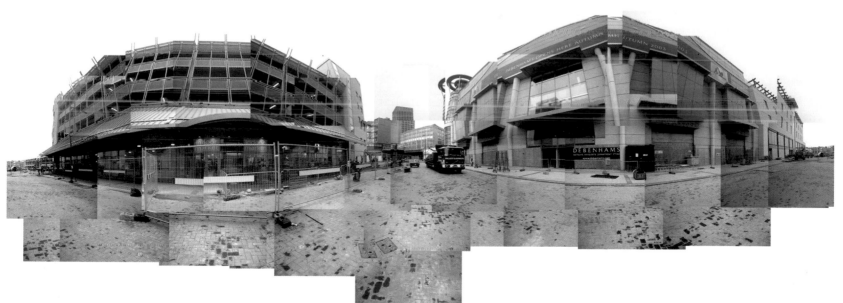

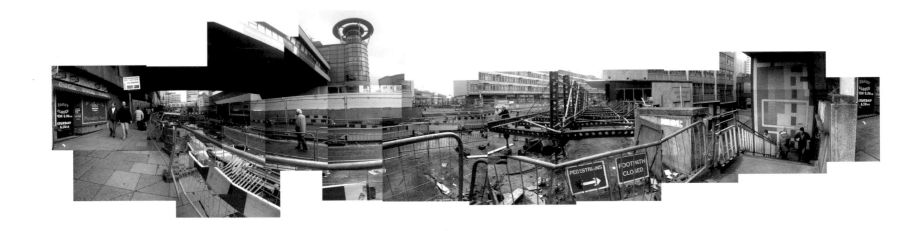

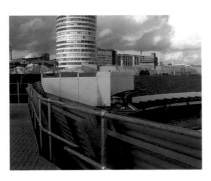
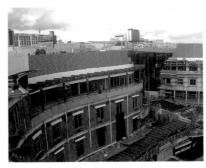
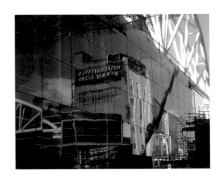

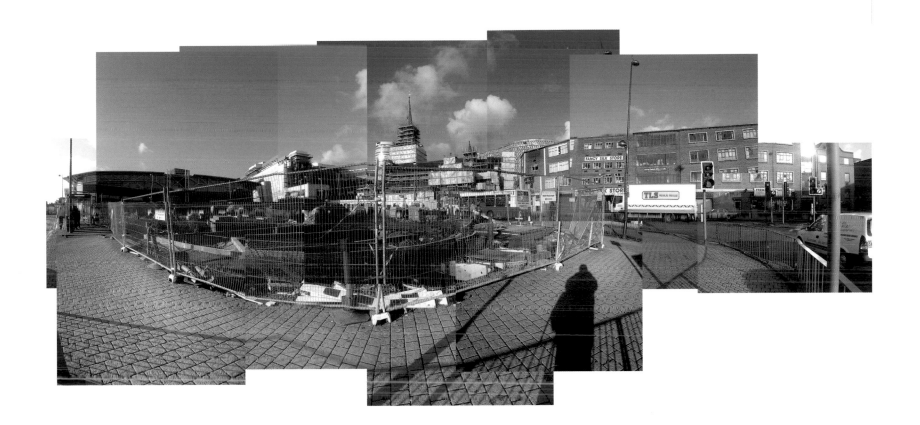

(Opposite) Construction on Smallbrook
Queensway, November 5, 2002. Inset of
various parts of the site on November 15,
2002. (This page) Refurbishing the site of the
Outdoor Market, December 4, 2002.

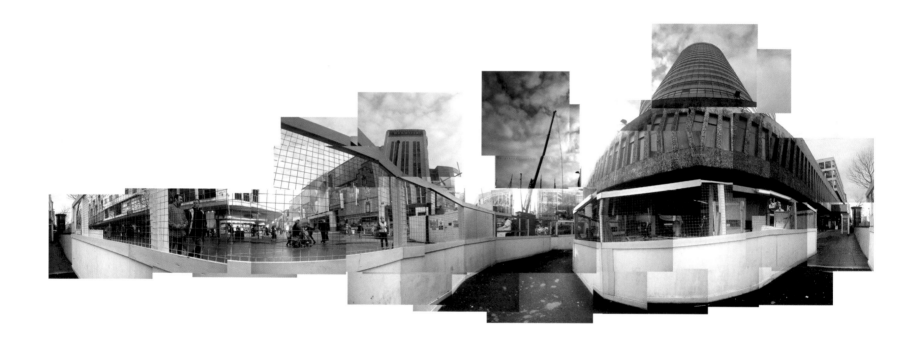

(This page) Temporary entrance to the
Rotunda, January 21, 2003. (Opposite)
Interior of site, January 23, 2003.

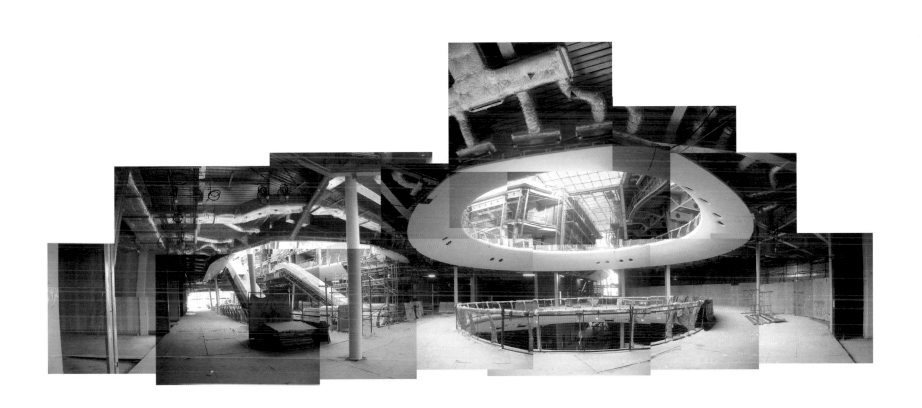

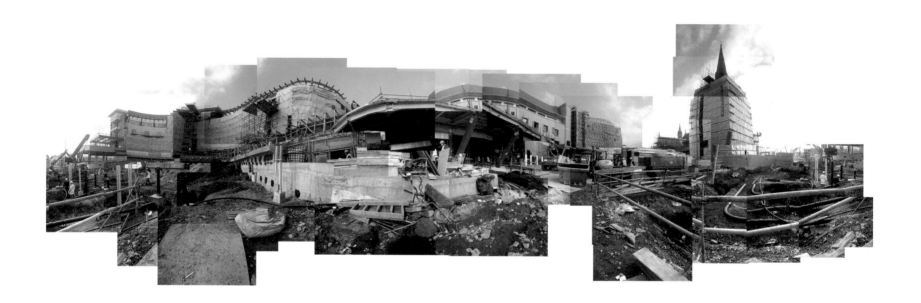

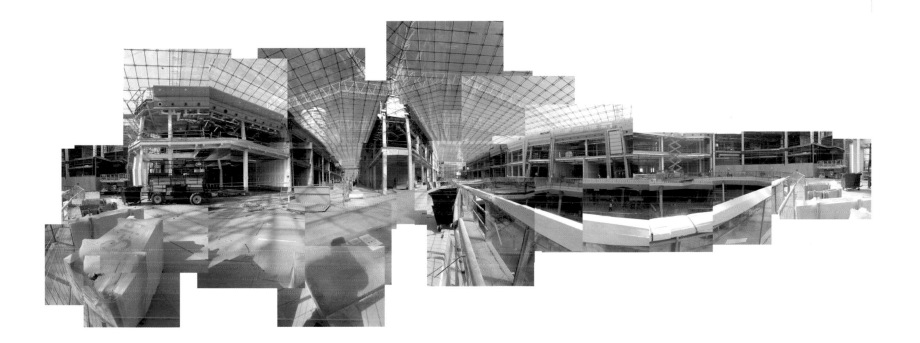

(Opposite) Three Wrapped Buildings. 360 degree panorama from the centre of the site, February 17, 2003. This construction is made from 53 individual photographs. (This page) 360 degree panorama of the interior showing Skyplane, March 12, 2003.

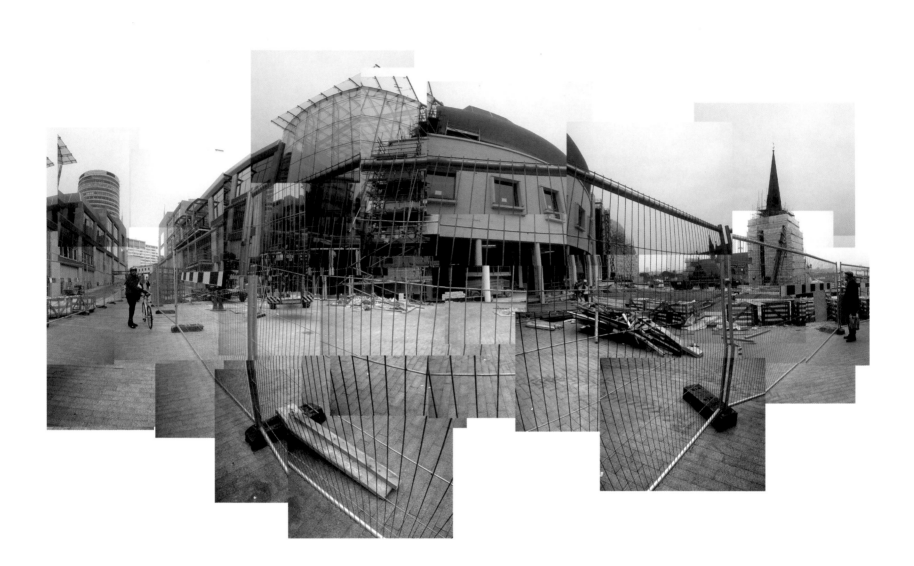

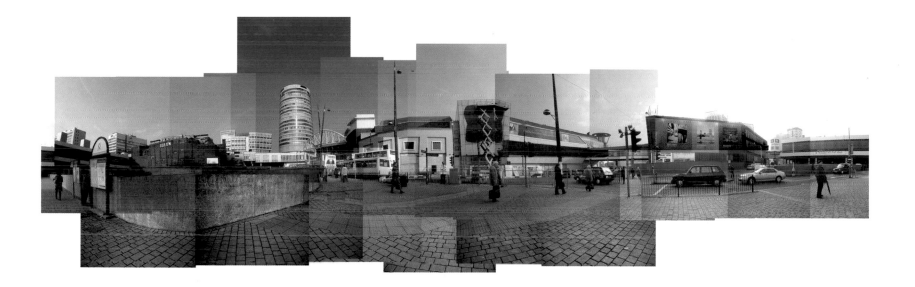

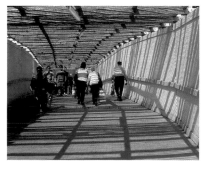
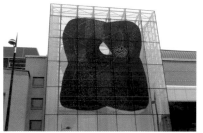

(Opposite) The opening up of the walkway from the Rotunda to St Martin's Church, February 20, 2003.
(This page) Facing New Street station. The Rotunda and the Debenhams store, February 25, 2003.

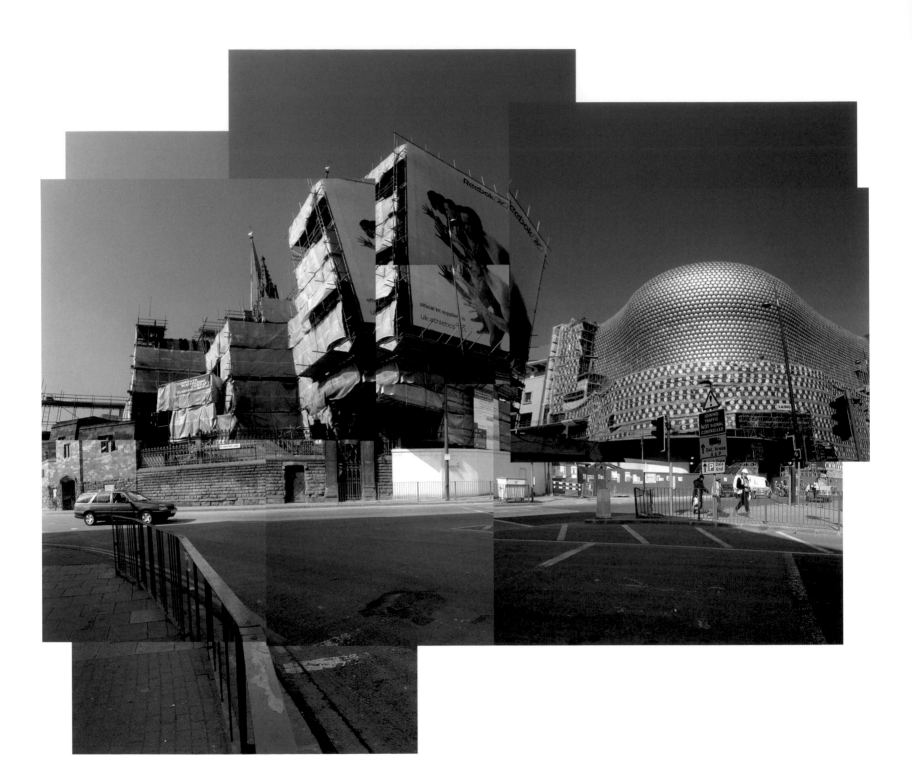

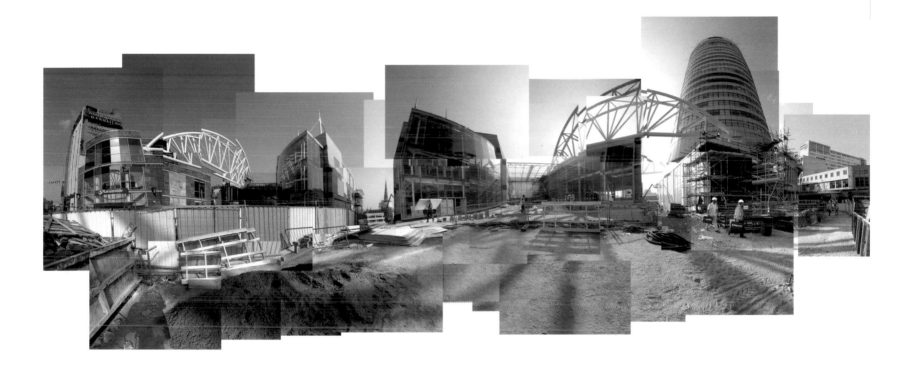

(Opposite) The Selfridges building and
St Martin's Church, March 17, 2003.
(This page) Bullring from the High Street,
March 25, 2003. Inset of bridge connecting
the Selfridges building to the new Moor
Street car park.

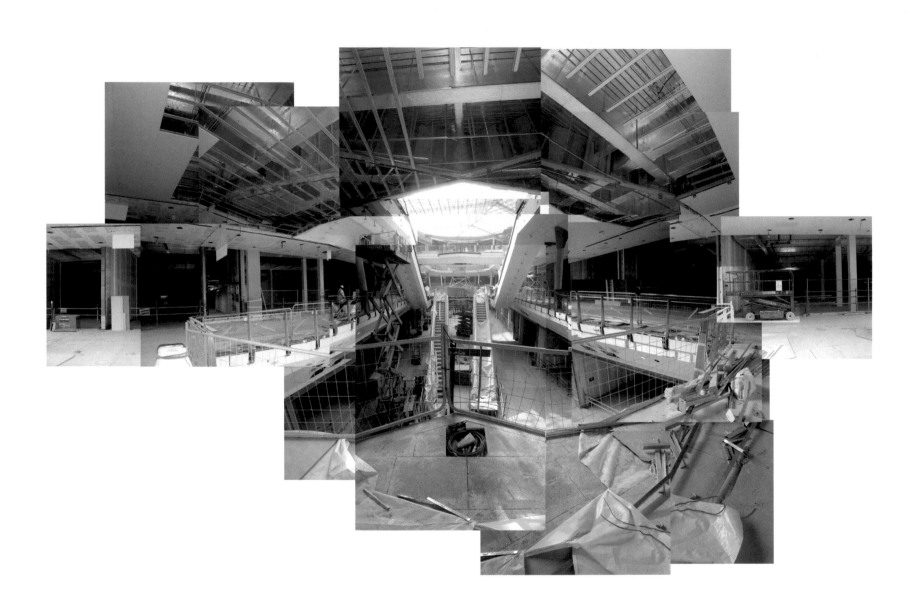

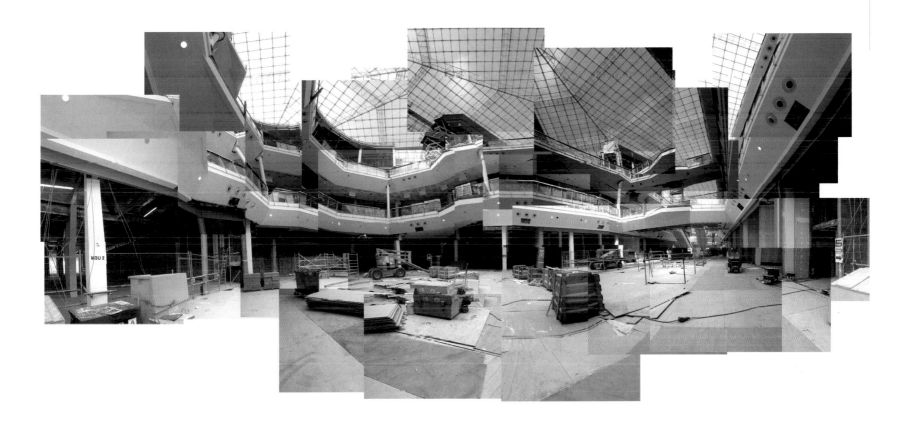

(Opposite page) Escalators in place in
the centre of Bullring, March 25, 2003.
(This page) Ground level interior,
March 25, 2003.

THE PEOPLE'S CHURCH

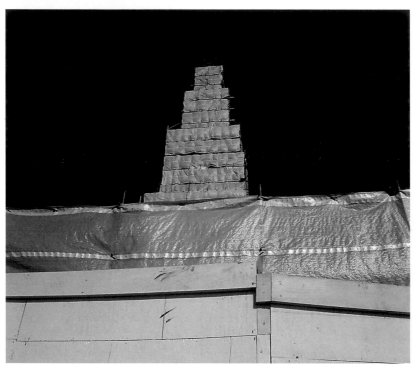

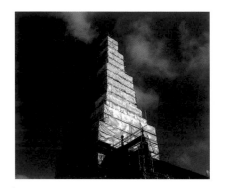

THE CHURCH OF ST MARTIN IN THE BULL RING

The neo-Gothic church was built in 1873 but age alone was not the main reason for its famously blackened exterior. The chief culprit was the city centre's high level of traffic pollution and its impact on the church's soft sandstone masonry. Statues of kings, saints and gargoyles had started to wear away; gutters and pipes were leaking badly.

If the Grade II listed building's run-down condition wasn't bad enough, its location, cut off by the inner ring road and surrounded by the claustrophobic concrete walkways of the 1960s Bull Ring, made restoration work difficult and was an extra deterrent for would-be worshippers or visitors.

The formation of The Birmingham Alliance in 1999 saw the emergence of an ambitious vision for the regeneration of of the city centre with a restored and beautifully illuminated St Martin's taking centre stage.

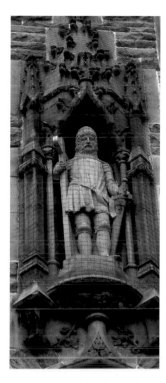
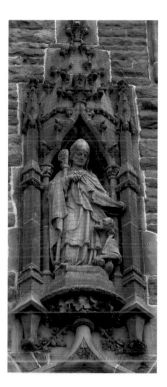

(Opposite) The wrapped up church during restoration, and (this page) the soft pastel coloured stone following restoration. Full-length figures depict St Martin as a soldier (left) and as Bishop of Tours (right). The outside pulpit on the north-west corner is the only one in the country and now overlooks St. Martin's Square. Photograph at lower left shows a section of masonry covered during the cleaning process.

BRINGING REALITY TO A VISION

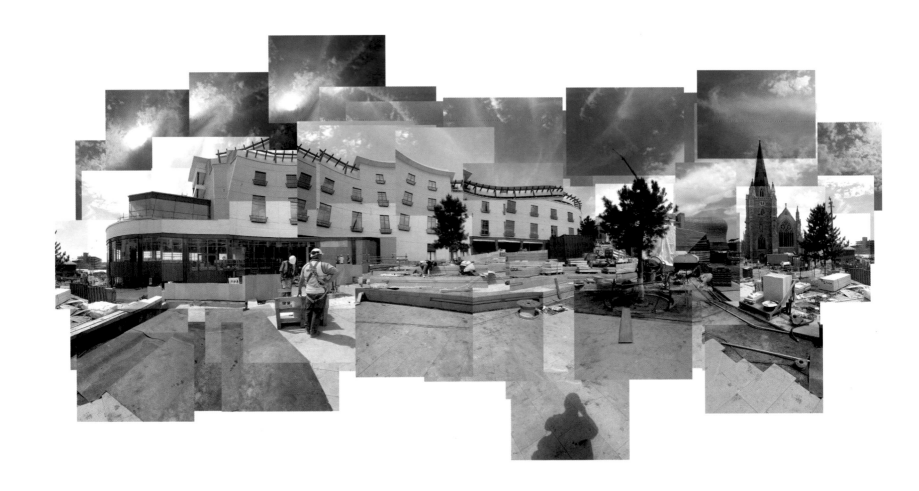

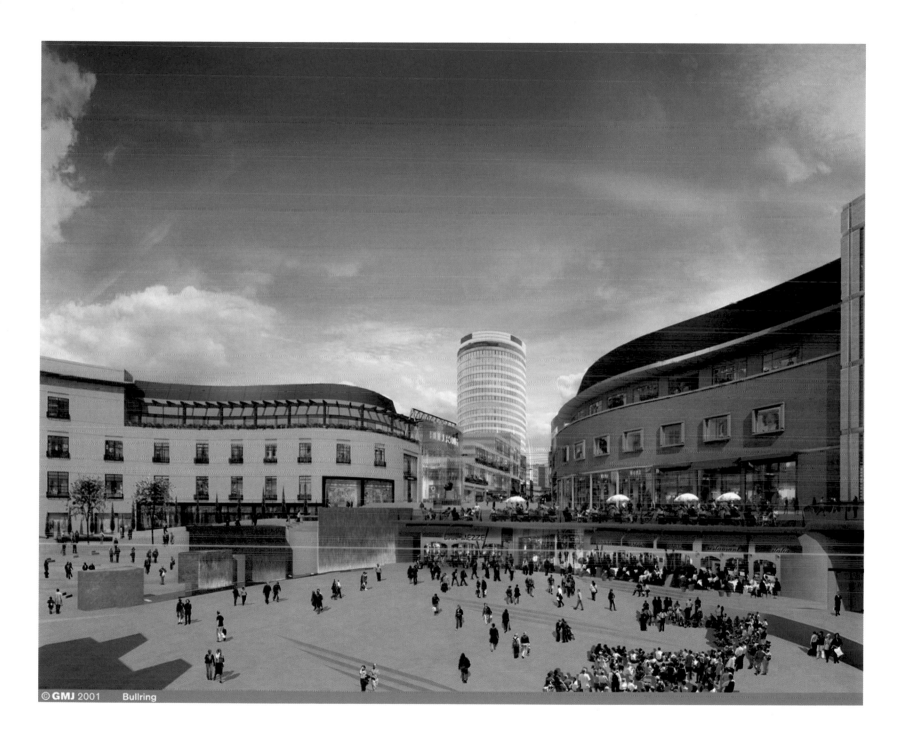

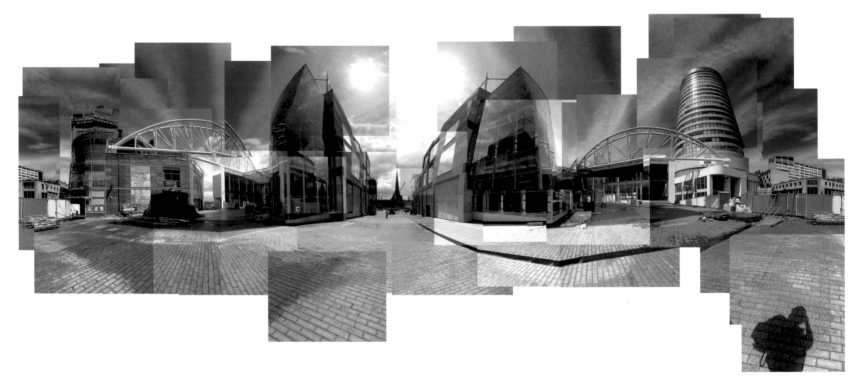

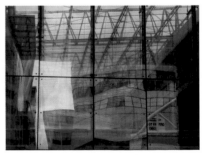

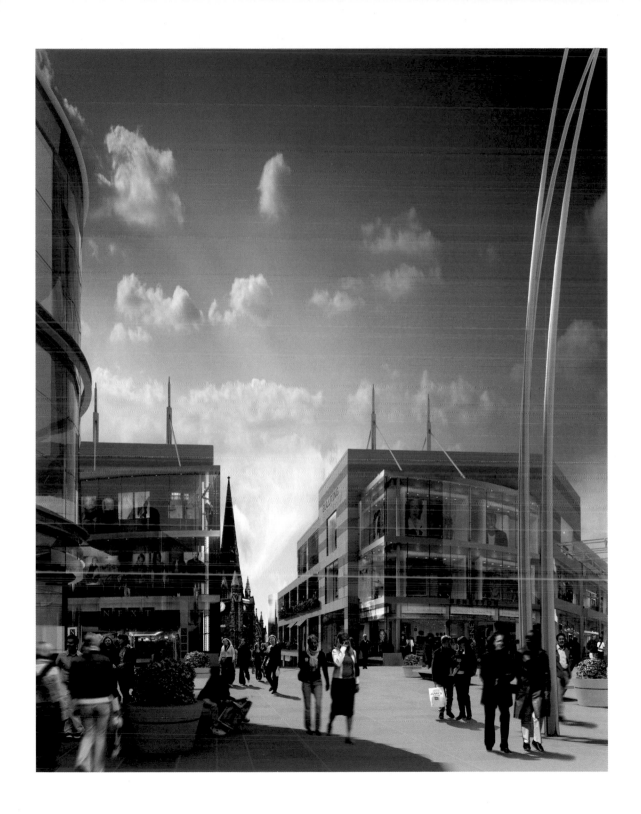

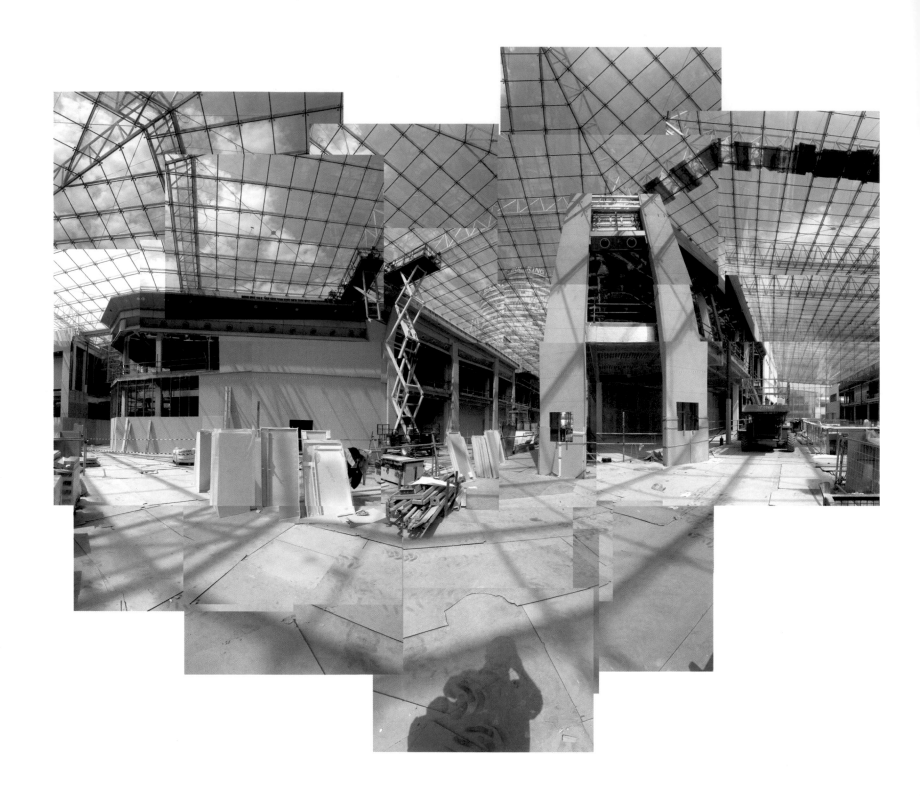

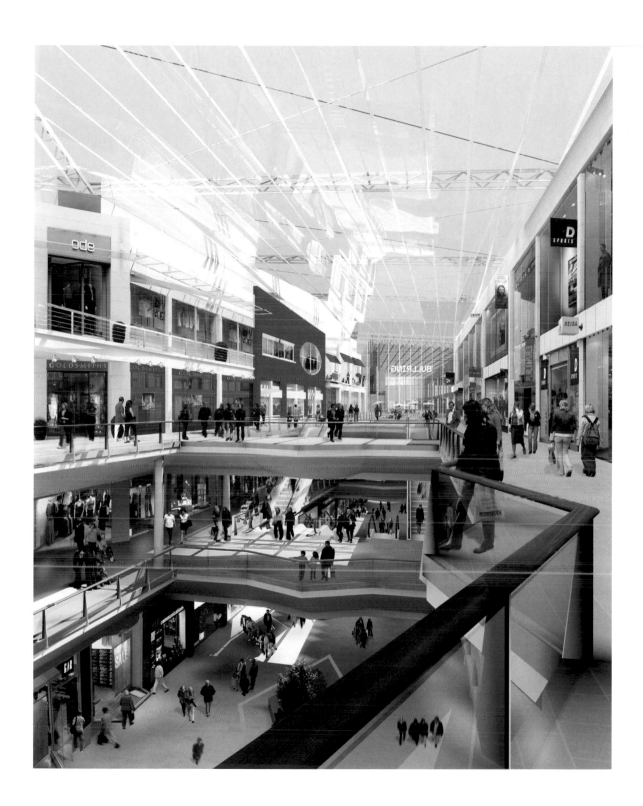

(Previous pages) The new public space in St Martin's Square; the view from the High Street near the Rotunda showing new buildings embracing St Martin's Church and the interior of Bullring showing Skyplane. Panoramic constructions made in the last few days of May 2003 are juxtaposed against computer generated images of the completed project.

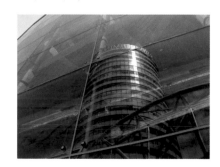

BIRMINGHAM'S RENAISSANCE

Stephen Hetherington

Hermits might like it, but there aren't many of those around. Solitude has its place and we all need it, at least in modest doses, but when you need a cash machine, when you feel like flirting, when you want music, ideas, conversation, fashion, friends and when you need to feed your soul with the shared food of human experience, there's nowhere to be but in a city. They ceaselessly conjure up a wonder of possibilities, with an intensity that at times can be overawing. They are a world without limits, both up and down.

The best cities are places where great learning and commerce feed off each other insatiably. This has been true of cities through millennia as it is true now. It is no coincidence that the city with three universities has one of the nation's oldest and largest markets. With arts and industry eyeballing each other across its Coat of Arms, Birmingham has even immortalised the idea. Juxtaposed with great artistic enterprises, libraries and academia are metal workshops, market stalls, densely packed offices and food from more nations than you could visit in a lifetime.

This market of England has it's doors open to everyone. A cultural mix of hundreds of nations, Birmingham is rich in humanity. Immigration over centuries has made it strong and inventive. From Germanic migrants of the 7th century, through French weavers and japanners, Italian workers of terrazzo, tailors and watchmakers from Poland and Russia, Irish navvies and engineers, Arab traders, Jewish immigrants driven by pogroms or opportunity, families of Asian, Chinese and Caribbean descent: Birmingham is the junction at which they have all met and at which they continue to meet. New immigration continues to reinvigorate the city, with the Somalian and Yemeni traders and restaurateurs setting up business and the recent influx of refugees seeking a foothold for a new future. The cultural collisions are fantastic. I have heard Japanese children play Jamaican dub. Qawali singers jam to flamenco. Jazz maestros play classical '60s Bollywood soundtracks. I hear Indian punk bands and electronic tabla masters. This is its culture: creative, energetic, industrious, rich and exotic as only a world city can be.

Stephen Hetherington

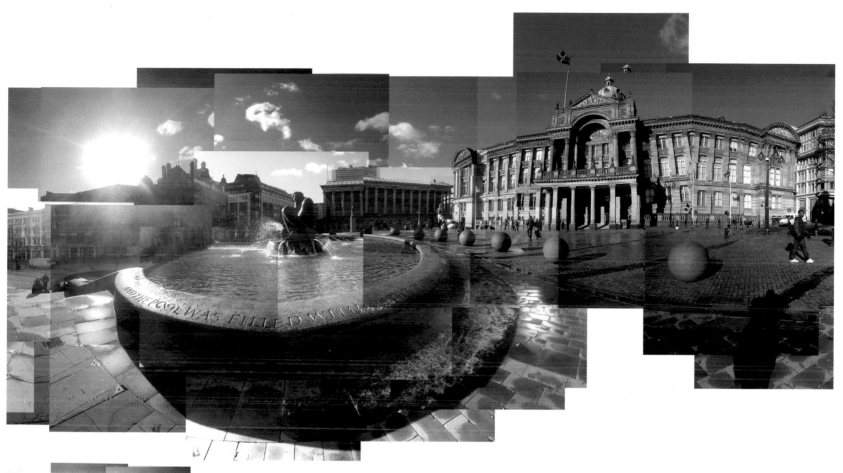
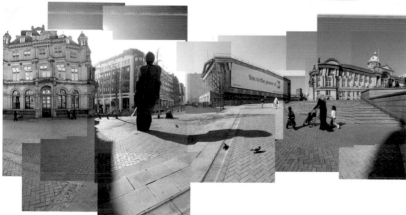

THE LIVING CITY

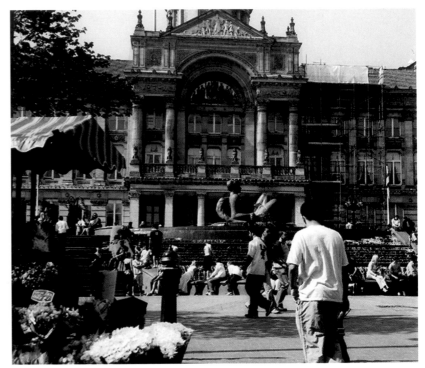

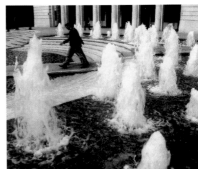

photographs by Gil Gillis

The diversity of the living city is seen through the colourful flower stalls in Victoria Square, eating out by the canals or in the Chinese Quarter, by visiting the Frankfurt Christmas Market, through learning in the library, living in the community of Castle Vale or by returning to Birmingham on a Virgin Voyager.

THE CREATIVE CITY

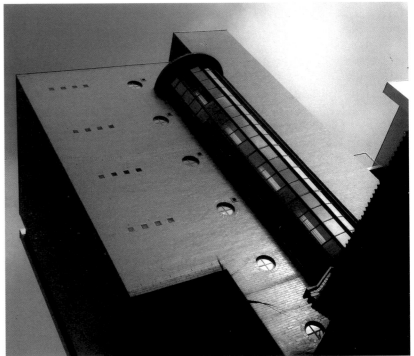

The creativity of the city is epitomised by the Custard Factory and the Jewellery Quarter, both areas with a long history in the city.

THE LEARNING CITY

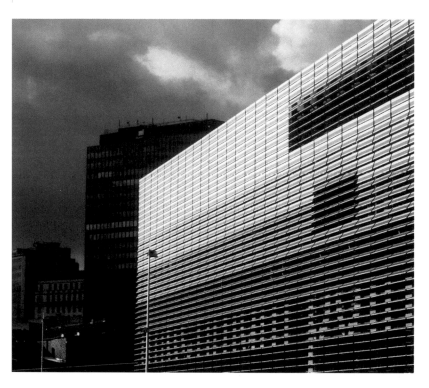

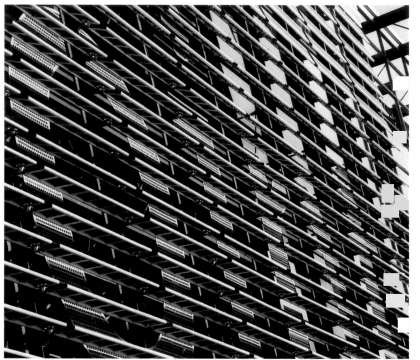

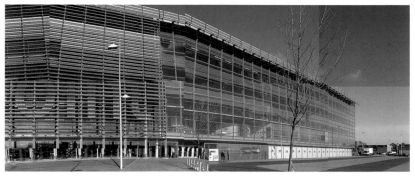

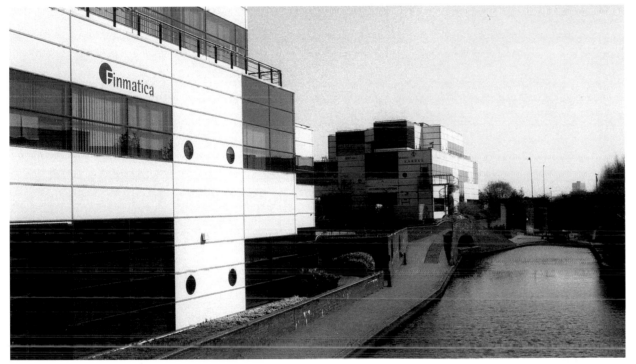

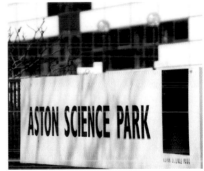

The learning city expands on the one-time 'city of a thousand trades'. At Millennium Point is Thinktank, the Technology Innovation Centre and the IMAX Cinema. Nearby the Aston Science Park redirects the intellectual energy of the city from manufacturing to high-tech design.

THE CULTURAL CITY

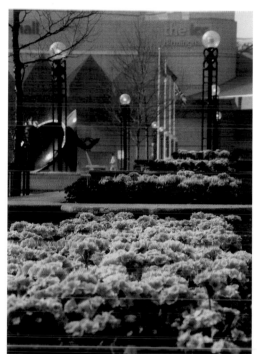

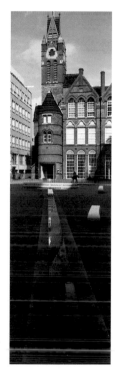

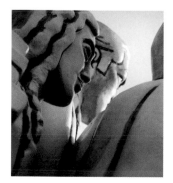

The cultural city is a delight for the senses and the soul. It provides uplifting experiences over a vast range of activities through art and architecture to theatres, concert halls and galleries. It has public art in public places. It is a city to be enjoyed.

THE CULTURAL CITY

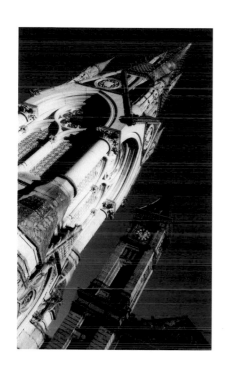
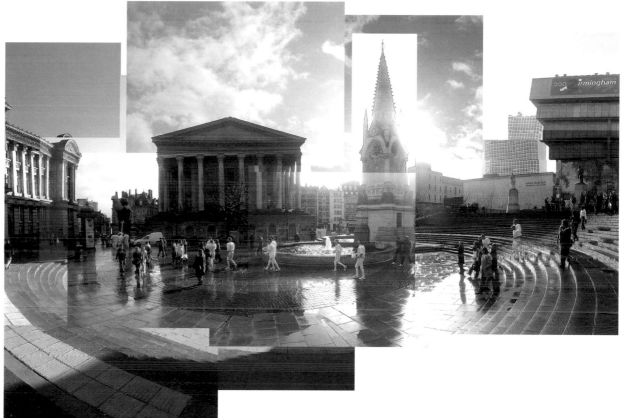

THE **BULLRING** PHOTOGRAPHY PROJECT

Michael Hallett using a Casio QV-5700 digital camera for his Bullring panoramic constructions.

By September 2003, 'the Bullring photography project' had run the course of its 33-month project period and produced between ten and twelve thousand individual photographs. These provided the basis for a contemporary archive, major exhibitions and a book published to coincide with the retail opening of the Bullring.

It was in the first few days of 2001 that almost by accident I stumbled onto the Bull Ring development. It was visually mind-blowing and crying out to be recorded for posterity. Buildings had been knocked down and rubble removed, leaving behind a large crater of red Birmingham earth. At one end of the site lay the '60s-built Rotunda and toward the other end the grime covered 19th century church of St Martin in the Bull Ring. Nearby the traders and their traditional markets were being dragged with some reservations into the 21st century. A pedestrian walkway at the top of the crater bisected the site from the High Street to the markets. Almost by stealth and without conscious decision-making, 'the project' began to have its own presence and slowly took over a large proportion of my working week. Previously and for nearly a quarter of a century I had worked in Birmingham, passing quickly from New Street Station to the university with little regard for Corporation Street or my surroundings. Even the local people were an inconvenience to be negotiated. All this was to change and for the better!

'The Bullring photography project' is a record of the construction of Europe's largest city centre retail led regeneration project. At over 40 acres and costing £500 million, it was driven forward by the Birmingham Alliance; a visionary partnership of Hammerson plc, Henderson Investors Ltd and Land Securities plc. The Bullring provides more than 110,000 sq m of prime retail space transforming the shopping heart of Britain's 'Second City', while new transport links and parking provides access for 7.2 million shoppers. A public space is created around St Martin's Church with pedestrian access from the High Street to the markets.

It is in these surroundings that you become part of the world of BBC Radio WM; of Ed Doolan, Malcolm Boyden and Carl Chinn. The locals are quick to engage with you: to recall their personal memories of the old Bull Ring, to share their pride of being a 'Brummie' and discuss their observations of the new project. Many of them carried rather battered cameras in their pockets or shopping bags, and many of them kept their own proud record of the planners' progress. They all had their favourite view of the site and were happy to disclose and discuss this with you. And for some unfathomable reason they all seemed to have relatives in Australia, New Zealand or Torquay and nowhere else. With the passing of time my camera and face became increasingly familiar around the market and on site, and greetings became a word, a nod, or a handshake. As Malcolm Boyden said on his lunchtime radio show, 'You are the Birmingham photographer. You are a Brummie through and through.' This honorary handle I carry with immense pride!

Individual photographs of Bullring seemed vaguely inadequate. A photograph can only be a representation of reality but somehow they seemed to miss the sense of space and excitement conveyed by visiting and observing the site. Visits to Berlin and Pittsburgh in the late 1990s, in themselves exemplars of city urban renewal, were now

by Michael Hallett

Michael Hallett challenges the concept of image making and reflects on the iconographic imagery that he calls the panoramic construction

echoed in discovering the Bull Ring development in the very centre of Birmingham. It was this sense of frustration that led me to pursue ways to extend the boundaries of time and space that a single exposure offers. The solution to exploiting more fully these amazing man-made edifices eventually became the 'panoramic construction'. Individual photographic images were placed over one another in layers rather than stitching and merging the images into one another. A recently acquired digital camera allowed me to photograph and piece together these early 180 degree panoramic constructions in the computer and so an innovative technique using cutting edge technology developed.

At that time there were visual limits to the changes between one briefly exposed underground car park level and another. As the days lengthened so did the frequency of my visits and from mid-summer until the end of the year they were in excess of one day a week. And as for so many other people involved with the Bullring the place for me took on a life and insistence all of its own.

Throughout the year the nature of the panoramic image changed to suit the subject. The 5-image 180-degree panorama remained a simple format while in the summer of 2001 a 360-degree panorama showing the retaining wall from the centre of the building site used 35 images. A commission from the Birmingham Central Library for a 165cm high 'upright panorama' in their new learning centre produced a document of 649 MB. Most images were the result of pre-determining the various elements in the mind. On occasions the panorama was ostensibly complete yet further waiting and watching suggested additional elements to the panorama, which once in place seemed intrinsic and absolutely essential.

From the early part of 2002 the site took on a new look. The majority of the steel work was complete and the outline of the construction was almost in its finished form. It was rather like the outline of a drawing that needed to be coloured in though this covering was to take much more time. The jewellry of steel poles and wooden planks became a common adornment. Other buildings were covered with sheets of canvas or plastic, only to be returned to our gaze with coverings of brick, stone or glass. Surfaces, textures and patterns were revealed in due course. The Selfridges building looked shockingly and wonderfully exciting with its plastic coat of white circles on a blue ground awaiting its final armadillo cladding. At the beginning of March a new pedestrian walkway was put in place. The route dropped south to the middle of the site and then took an anticlockwise arc to the entrance of St Martin in the Bull Ring Church, following the footprint that would become St Martin's Walk when the development was completed. From June the church became hidden underneath scaffolding as part of its own renovation programme.

'BULLRING Preview' was unveiled at *Focus on Imaging* at the NEC, Birmingham in February 2003. Mary Walker agreed to host this preview exhibition and Loxley Colour sponsored and printed the twelve one meter wide images. Images at this scale showed detail that had previously been hidden. A more modest exhibition of work in progress was also showing in the foyer of the Birmingham REP to coincide with *Wallop Mrs Cox*, the highly popular and successful community musical about a family of Bull Ring traders.

It was about this time that the more public areas of Bullring began to be returned to the people. A portion of

the walkway from the Rotunda was dismantled revealing the block paving and the eventual route of St Martin's Walk. Almost simultaneously the removal of the protective covering began to reveal the top of the Selfridges building, a striking, curvaceous shell with 15,000 spun aluminium disks. The public space around St Martin's Church was beginning to take shape and the wide piazza between Debenhams and the markets became more evident.

As curator of the exhibitions as well as co-editor of the book, Peter James began to have a more insistent voice and vision of the outcomes of the project. The effect was a more perceptive and rounded view than had originally been anticipated. From the turn of the year Gil Gillis joined the team as project manager. With a background in commerce and regeneration, he took great delight in moving the project on and bringing it to a larger and more catholic audience than would otherwise have been the case. In the book he has his own camera vision of Birmingham's renaissance, while Luke Unsworth's remarkable photographs of the old Bull Ring and its demolition offer a resonance and poignancy that looks back at this onetime city of a thousand trades. His black-and-white images are a powerful reminder of what has gone before. Essays by Chris Upton and Peter James put the Bull Ring and Bullring into a current context and their selection of key illustrations and photographs gives the book a popular and historical place. What started as a one-man effort came to a fitting conclusion as a team effort.

The book, a series of photographs with introductory essays, is part of a genre exemplified by Walker Evans' book *American Photographs* (1938) and Robert Frank, *The Americans* (1959). The panoramic construction has links with the photographer as printmaker while the inkjet printer is the latest form of markmaking previously enjoyed by engraving and lithography. There are further links with social anthropology and with Lee Friedlander's American street photography.

On one level the constructions are complete in themselves while on another they become part of the larger construction making the double page spread. The interaction between image and text, positive and negative space heighten this level of communication. The scale of the individual images moves the pace of the story along.

'The Bullring photography project' as an exhibition and a book describes a vision. With the retail opening the shared vision of so many people from the public and private sectors was achieved. With Bullring we have a big project that retains a human scale. Here is complexity and simplicity, a place where people can be both comfortable and amazed.

In constructing these panoramic images there has dawned a realisation of being a small part of history in the making. There is an added sense of achievement in that these images depict the development of an amazing spectacle of consumerism. These are truly iconographical images. In this 21st century the world has moved forward, along with a growing awareness that Birmingham has becoming a vibrant metropolis where people enjoy living their lives. Bullring is at the very heart of this.

THE CONTRIBUTORS

Michael Hallett

Peter James

Gil Gillis

Michael Hallett MPhil, FBIPP, FRPS, FCSD, MCMI is a professional image-maker of wide experience and is an internationally published photographic historian. With *Bullring* he returned to his original career of photography.

Peter James MA is Head of Photographs at Birmingham Central Library and Chairperson of the Committee of National Photography Collections. He has curated major exhibitions in Birmingham and London and is published internationally. He is curator of the exhibitions.

Gil Gillis BA(Hons) LRPS ACIB came to the project with considerable commercial and regeneration senior management and board level experience. He is project manager for the Bullring photography project.

Luke Unsworth BA(Hons) is an experienced freelance photographer in documentary and corporate imaging. Clients have included Birmingham City Council and Library, Hammersons, Birmingham Alliance, Millennium Point and Carlton Television.

Chris Upton PhD MA is an eminent Birmingham-based academic and local historian, widely published in his own right. He is a weekly columnist for the *Birmingham Post* and a regular contributor to radio and television.

Luke Unsworth

Chris Upton

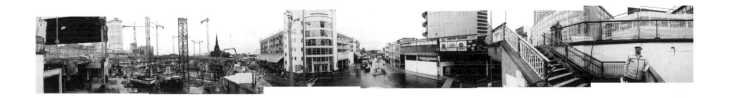

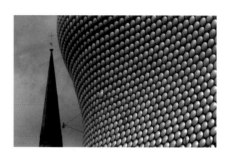